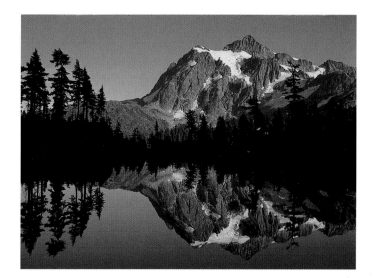

WASHINGTON

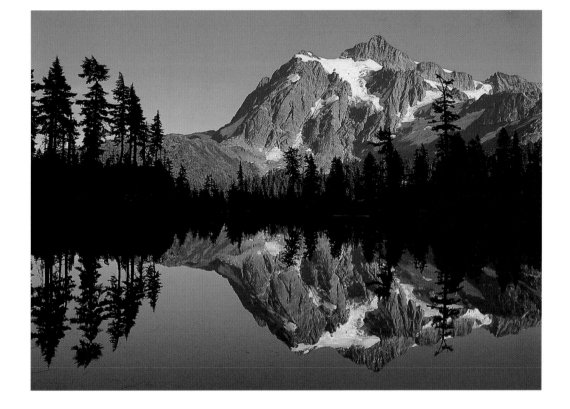

WHITECAP BOOKS

Text by Tanya Lloyd
Edited by Elaine Jones
Proofread by Elizabeth McLean
Photo Editing by Antonia Banyard
Cover and interior design by Steve Penner
Desktop publishing by Susan Greenshields
Printed and bound in Canada

National Library of Canada Cataloguing in Publication Data

Lloyd, Tanya, 1973–
 Washington

 ISBN 1-55110-862-3

1. Washington (State)—Pictorial works. I. Title.
F892.L66 1999 979.4'043'0222 C98-911020-6

The publisher acknowledges the support of the Canada Council and the Cultural
Services Branch of the Government of British Columbia in making this publication
possible. We acknowledge the financial support of the Government of Canada through
the Book Publishing Industry Development Program for our publishing activities.

For more information on the America Series and other Whitecap Books
titles, please visit our web site at www.whitecap.ca.

The Evergreen State is an amazing patchwork of contrasting landscapes—idyllic orchards and jagged mountain peaks, rolling farmland and dramatic beaches. In one corner of the state, lush rainforests receive more precipitation than anywhere else in the country. In the opposite corner, rolling hills are swept by a dry southwest wind. In the Cascade Mountains, more than 300 glaciers top the peaks. It is this diversity that makes Washington unique.

In the northwest, rainforests blanket the Olympic Peninsula, and giant evergreens reach heights of 300 feet. This untouched beauty is just a weekend's getaway from the bustling heart of downtown Seattle, one of the emerging centers of Pacific Rim commerce. Here, Douglas firs and towering buildings stand side by side, to create one of the country's most distinctive cityscapes.

And this is just one piece of the patchwork. To the south, Long Beach is a combination of sand dunes and crashing waves, attracting tourists and kite fanatics from around the world. The carnival-like atmosphere of the beachside town contrasts with the area's reputation as the graveyard of the Pacific. Hundreds of ships have foundered here, where the mighty Columbia River creates unexpected dangers.

A foil to the drama of the coast, the farmland in eastern Washington is a serene combination of rolling hills, tilled fields, and picturesque farming communities. One of North America's top wheat-growing areas, the Palouse also harbors surprises, such as sudden peaks and rugged canyons.

In *Washington*, some of North America's best photographers have captured the state's sights and events, viewpoints and festivals. These images are a celebration both of its people and its natural wonders.

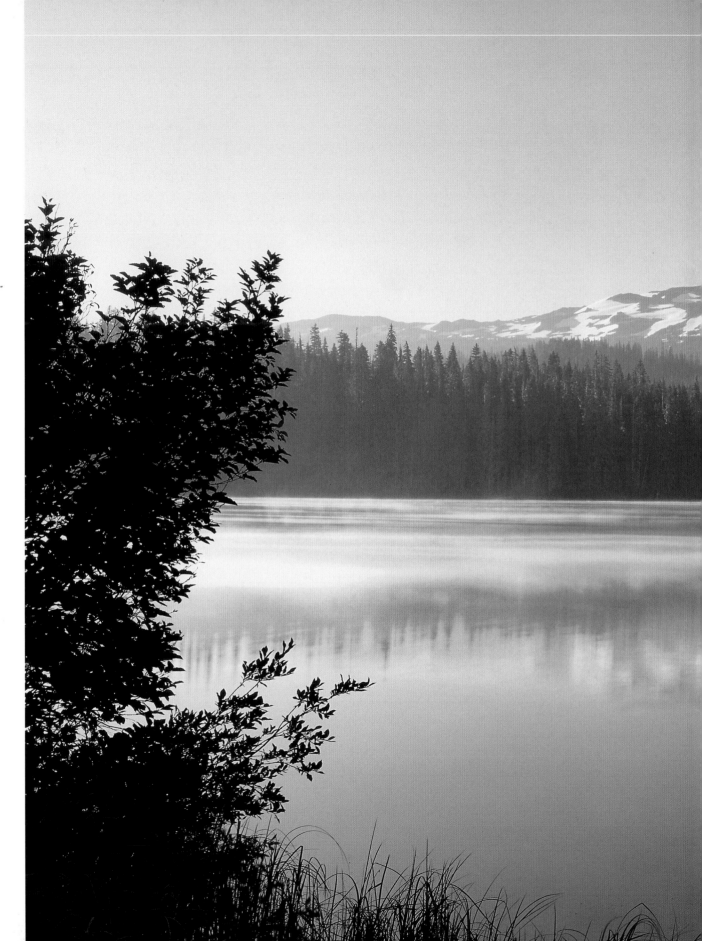

The 42,411-acre Mount Adams Wilderness is dominated by the towering 12,326-foot peak. According to native legend, Mount Adams and Mount Hood were brothers, transformed into mountains after warring for the attentions of the maiden Loowit.

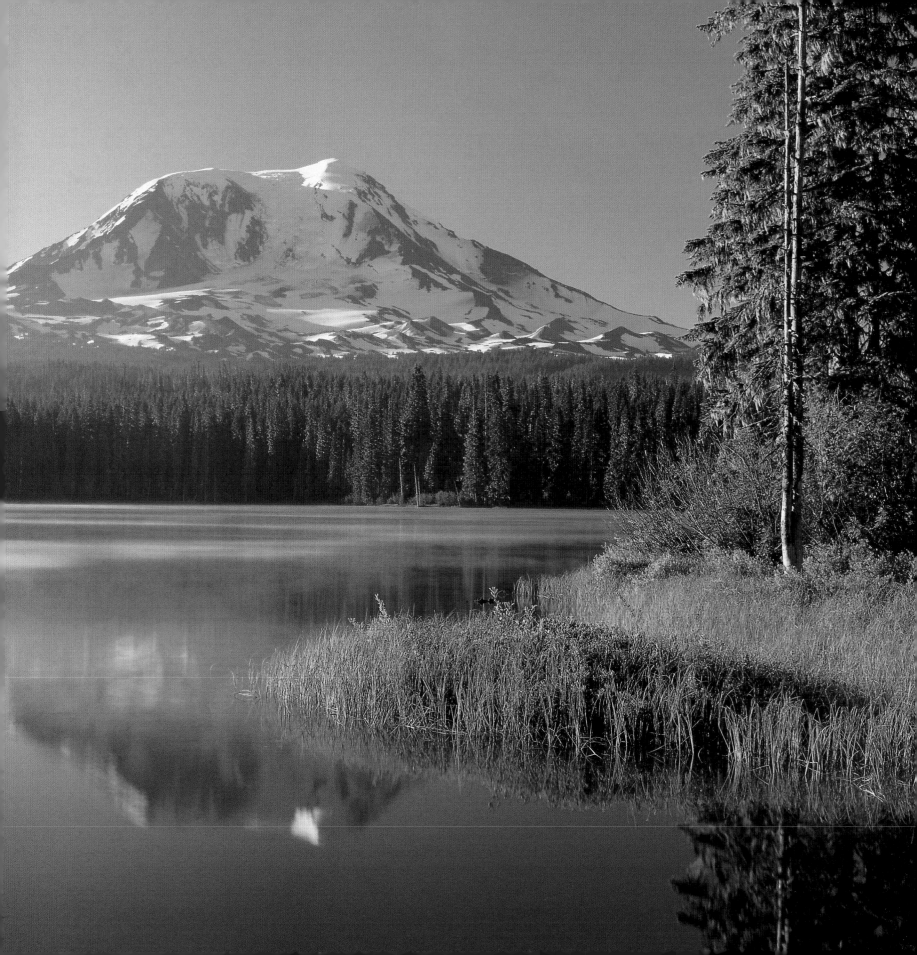

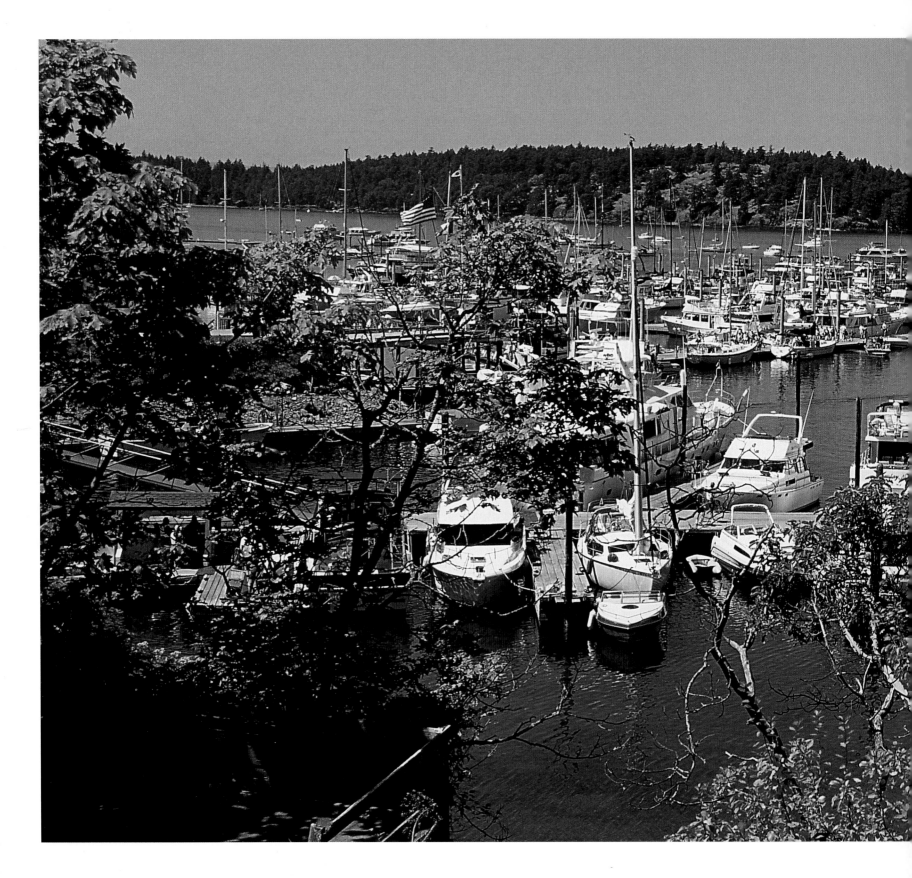

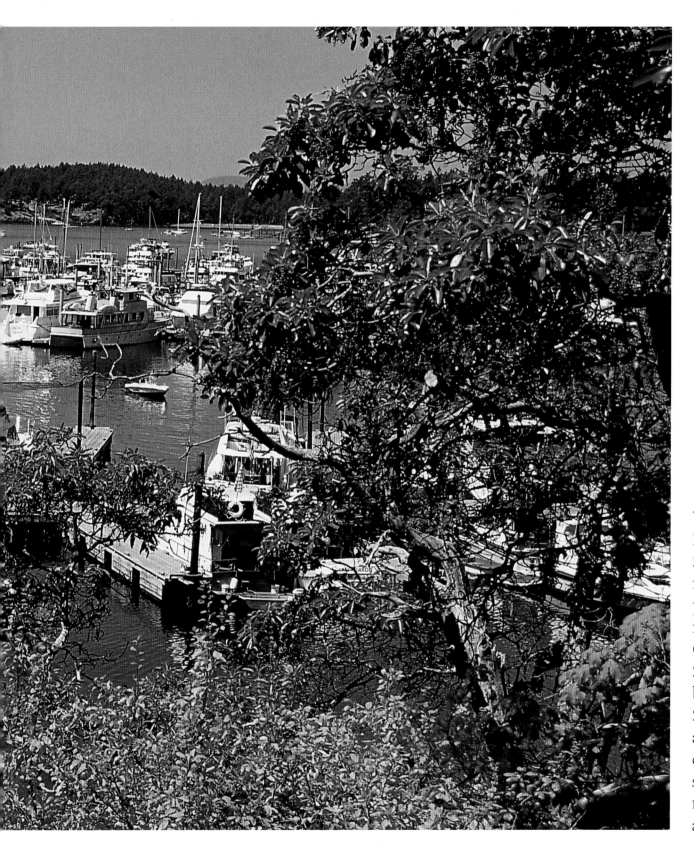

There are more than 200 islands in the San Juans, some un-inhabited and some privately owned. Four islands — Lopez, Orcas, San Juan, and Shaw — are served by the Washington State Ferries and appeal to the tourist crowd with amenities such as campgrounds, markets, and bed and breakfasts.

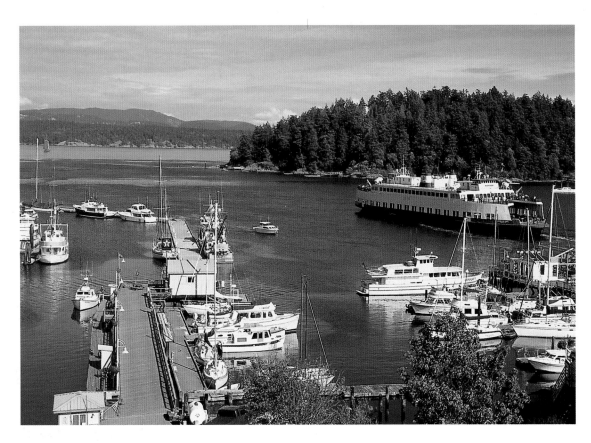

Washington State Ferries is the country's largest ferry system. It shuttles vehicles and passengers up and down the coast, between the San Juan Islands, and even to Vancouver Island in British Columbia. This vessel is departing from Friday Harbor on San Juan Island.

The Emmanuel Episcopal Church on Orcas Island was built in 1886 and adds to the island's reputation as the most beautiful of the San Juans.

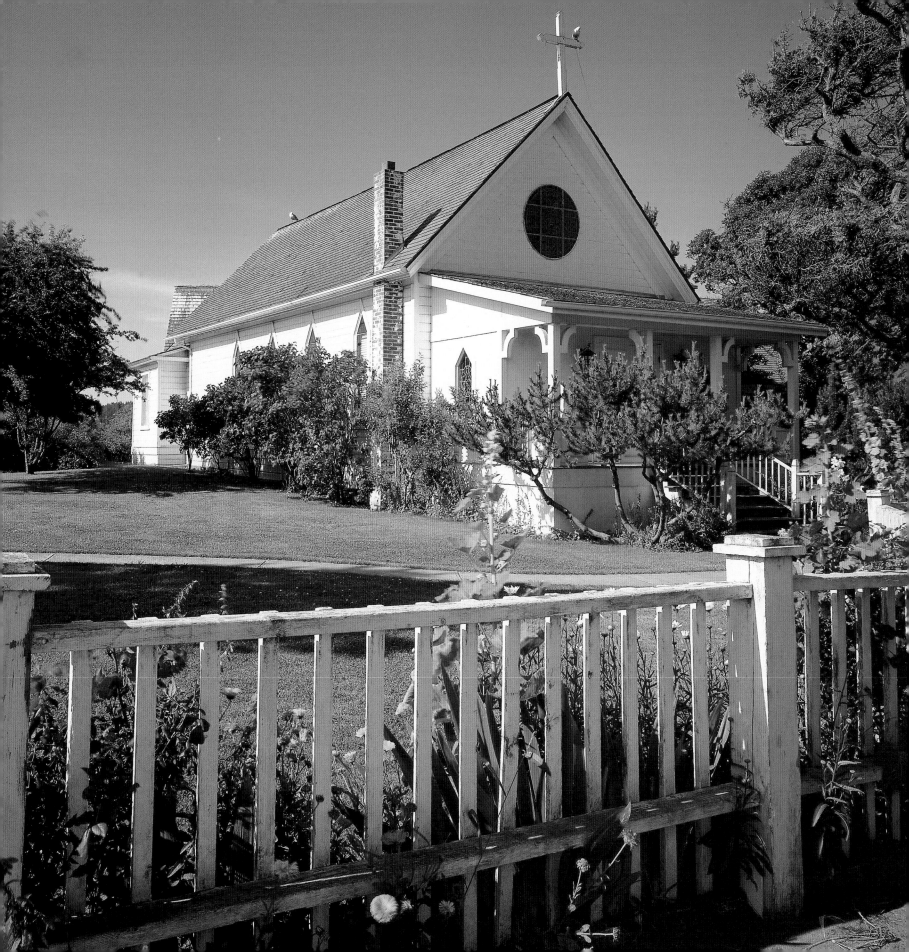

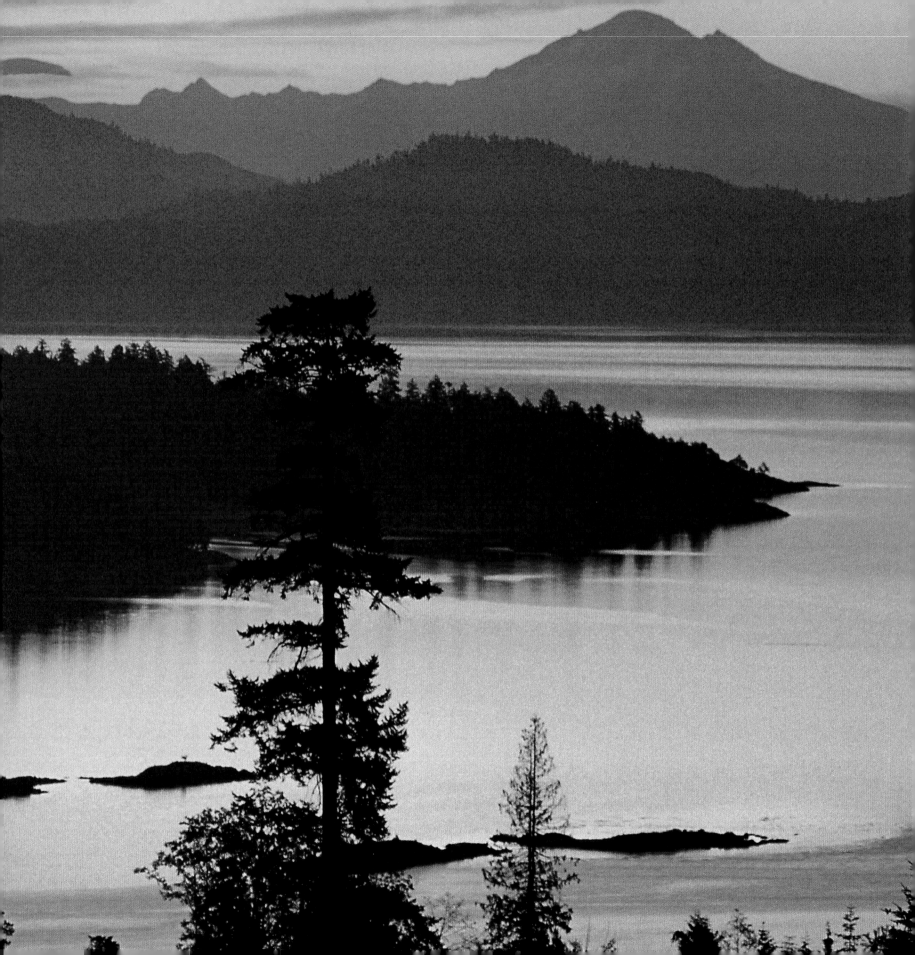

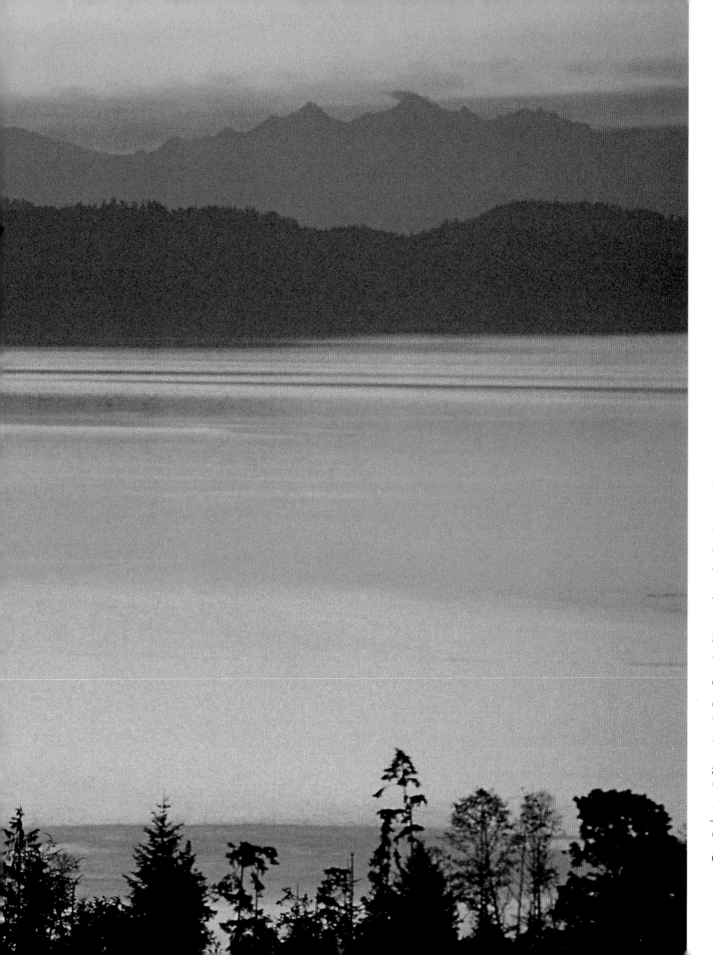

Canada's Gulf Islands and Washington's San Juans are part of the same island chain. The boundary was decided after an American San Juan Island resident killed a British neighbor's pig in 1859. The ensuing dispute, called the "Pig War," lasted 13 years. No shots were fired, and the boundary between the San Juans and the Gulf Islands was established in 1872.

Chuckanut Drive winds
for seven miles along
the scenic shoreline
south of Bellingham.

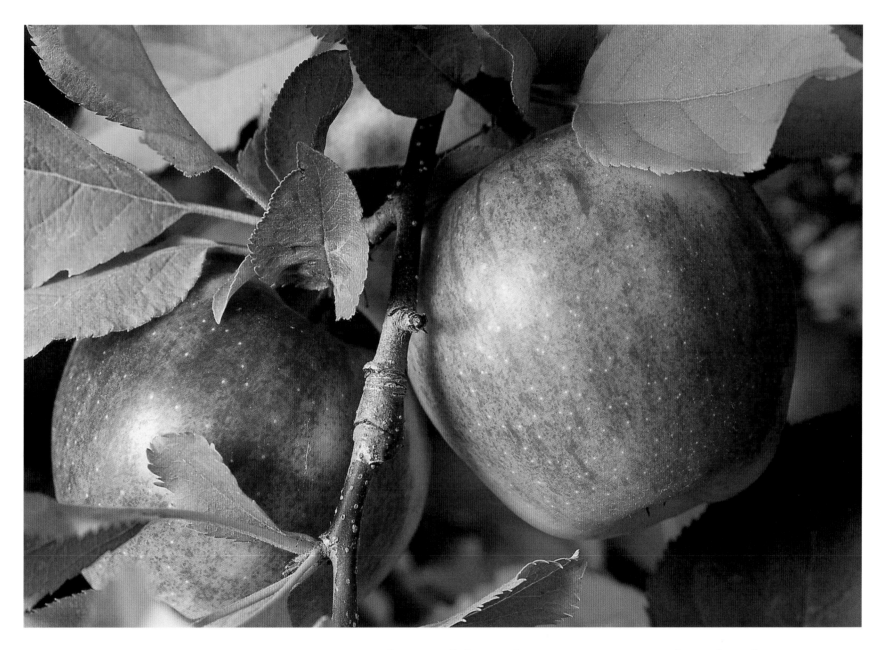

Employees of the Hudson's Bay Company planted apples, among other crops, in the early 1800s. Today, the state produces over half of America's apples — 2.5 million tons each year.

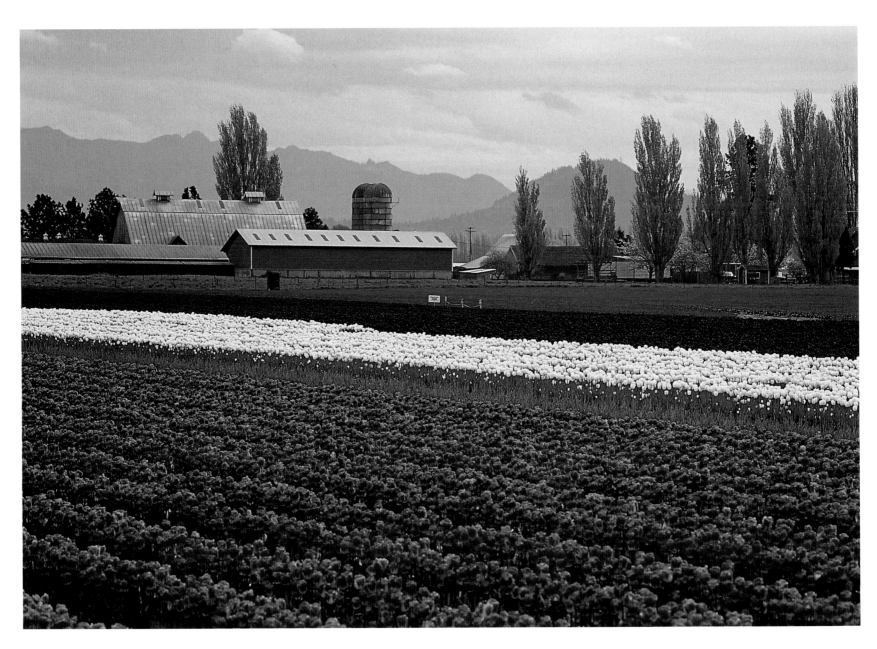

The ten-day tulip festival draws thousands of visitors each year to
the La Conner area. As well as tulips, farmers in the region produce
daffodils and other flowers, vegetables, and more than a third of
America's peas.

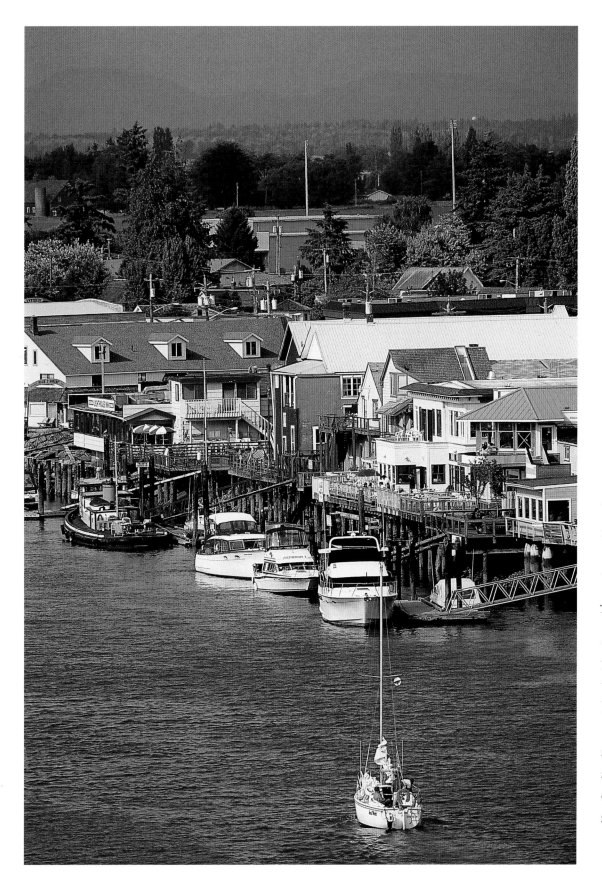

La Conner is named after Louisa A. Conner, wife of the town's founder, John Conner. The boardwalks and character homes remind visitors of the town's long history. It was settled in the 1800s and served as a fishing port and a commercial center for the surrounding farms.

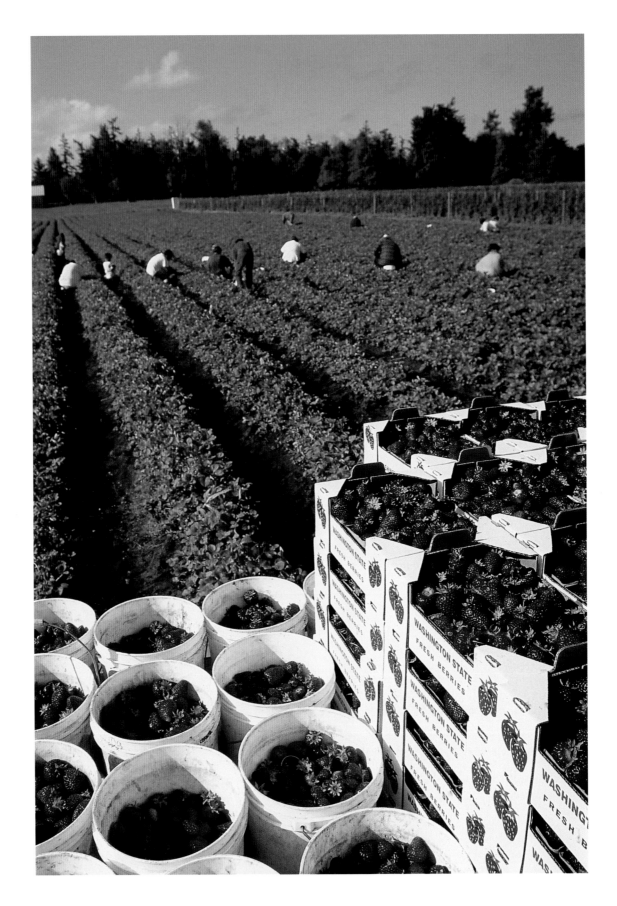

Washington is the nation's fifth-highest producer of strawberries, cranberries, and blueberries. Strawberries alone contribute about $5 million a year to the state's economy.

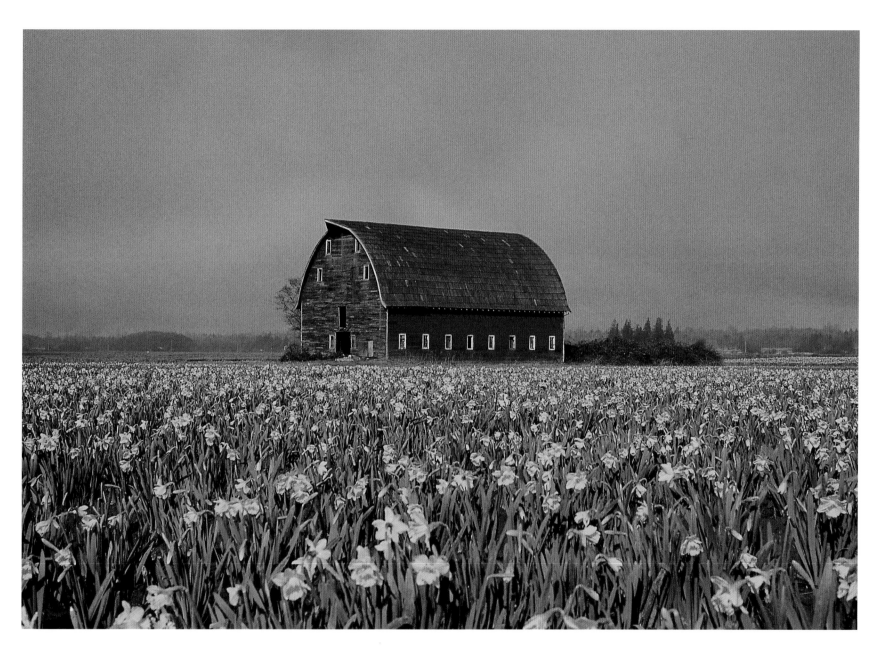

Picturesque scenes such as this draw many visitors
to the backroads of northwest Washington.

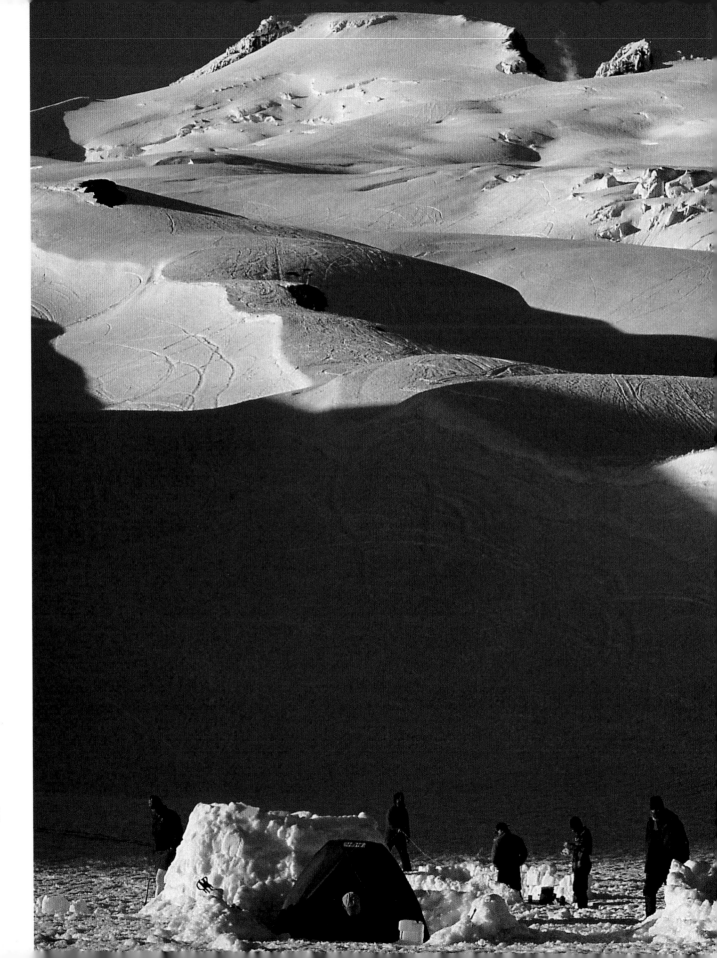

Mount Baker is one of the Cascade Range's active volcanoes. Although there have been no major eruptions in the past 10,000 years, the mountain occasionally belches clouds of steam and dust. The range forms part of the Ring of Fire, a string of volcanoes circling the Pacific.

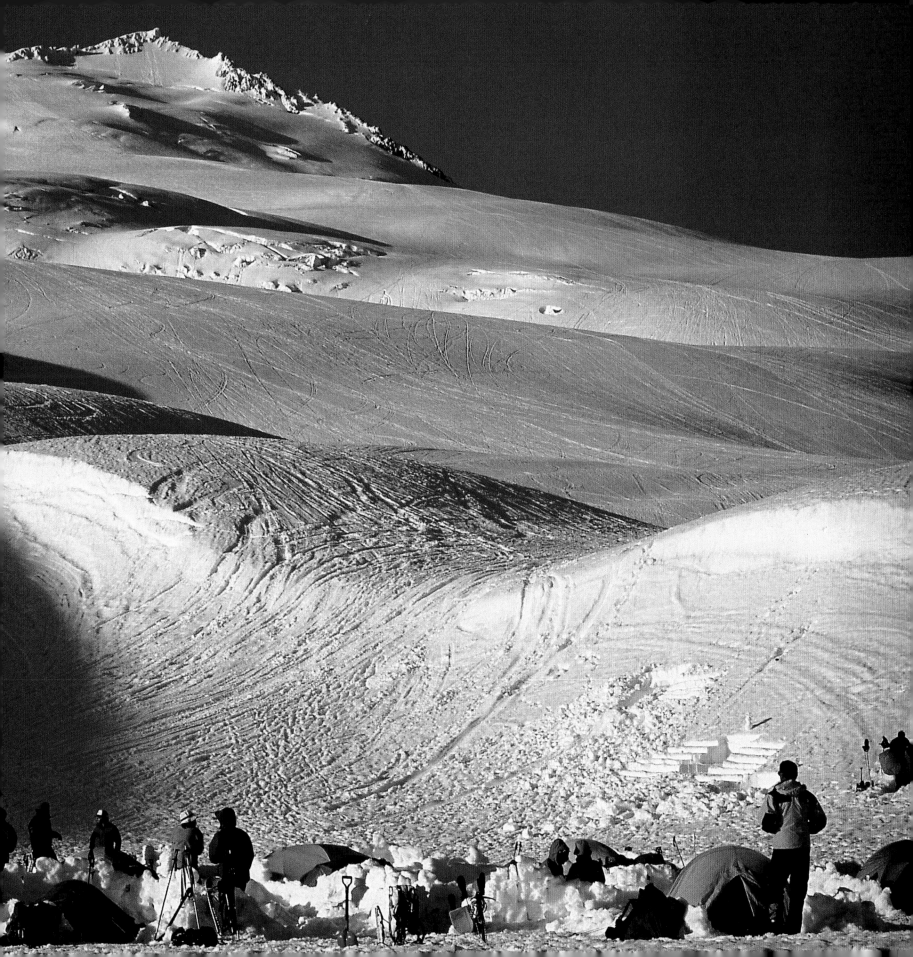

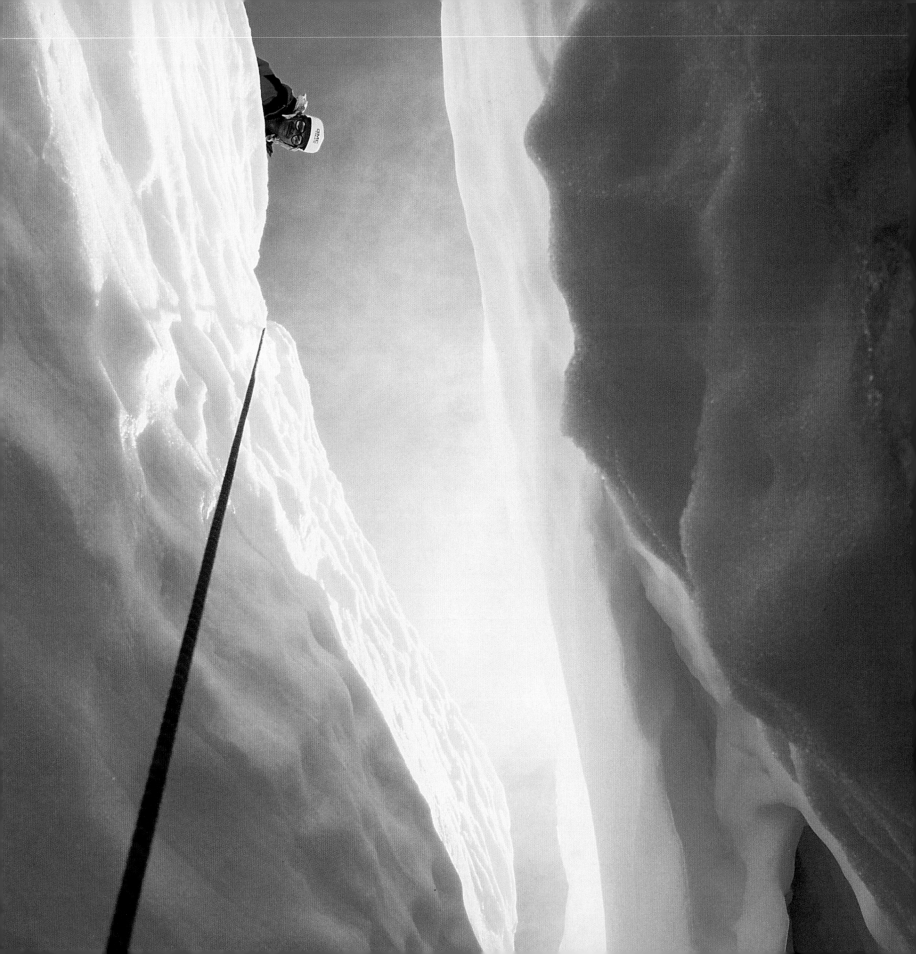

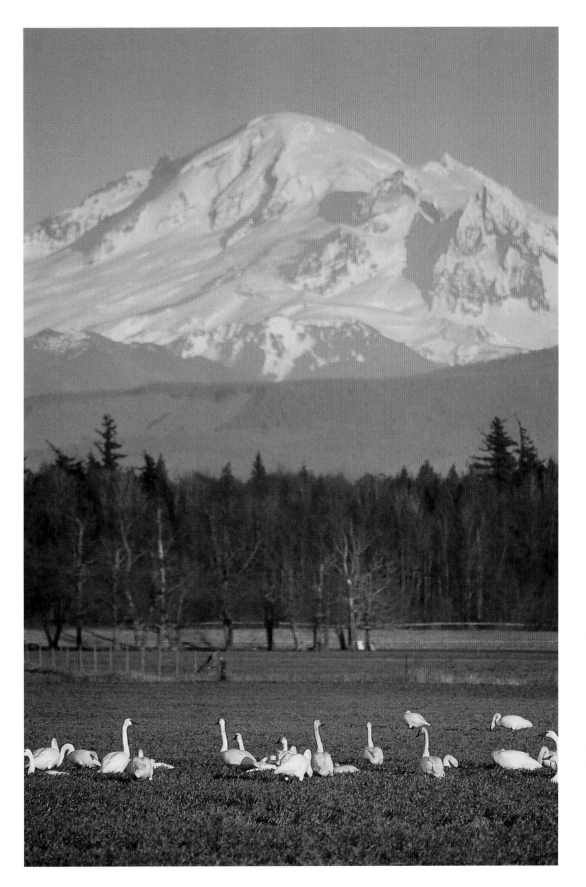

The trumpeter swan, the largest of America's waterfowl, was hunted to the brink of extinction in the early 1900s. With strict conservation measures in place, its numbers are now slowly growing.

OPPOSITE —
The first group of climbers reached the summit of Mount Baker in 1868. Two hundred miles of trails now lead hikers and backpackers up the slopes. The mountain is also known for its history as a ski hill. This was one of the birthplaces of snowboarding in the 1980s.

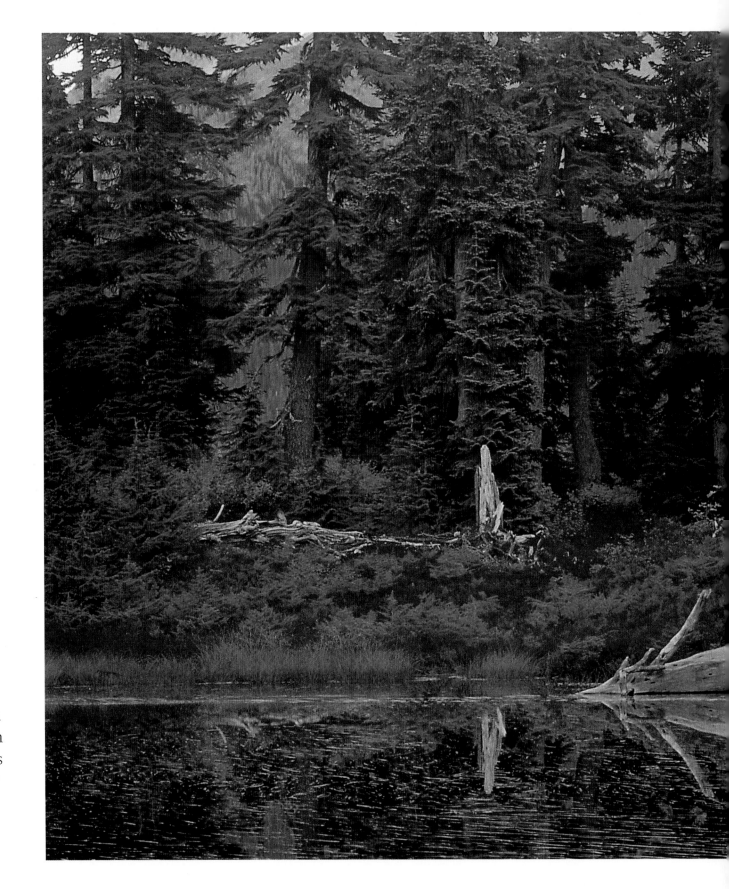

Like many Washington landmarks, Mount Baker and Mount Baker Wilderness were named after a member of Captain George Vancouver's crew. Joseph Baker was first mate on the 1792 voyage.

24

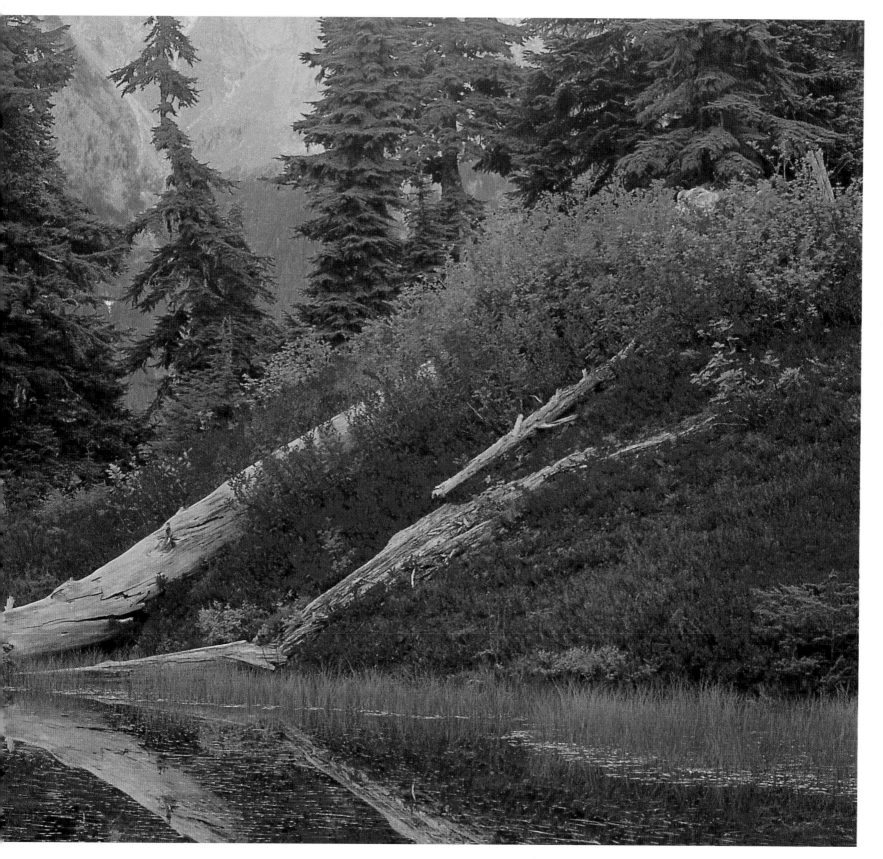

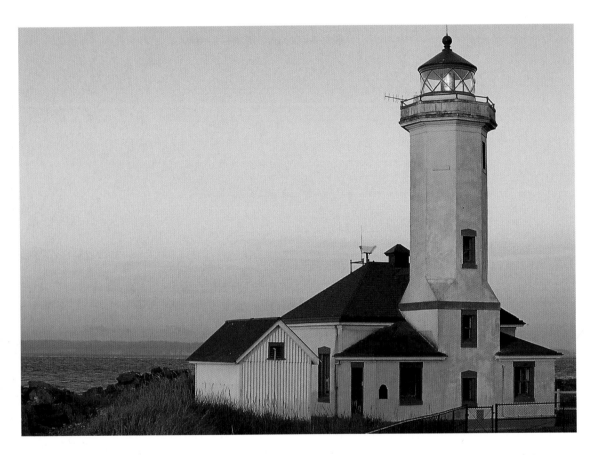

The Point Wilson Light Station is part of Fort Worden State Park, the setting for *An Officer and a Gentleman*. The fort was built in 1855 as part of a trio of forts intended to protect Puget Sound from invasion. It now boasts restored officer's quarters, fort buildings, and sandy beaches.

Port Townsend is filled with reminders of its varied past. National historic districts preserve the Victorian mansions of 19th-century merchants, and the harbor reminds visitors that Port Townsend was once one of the state's busiest ports.

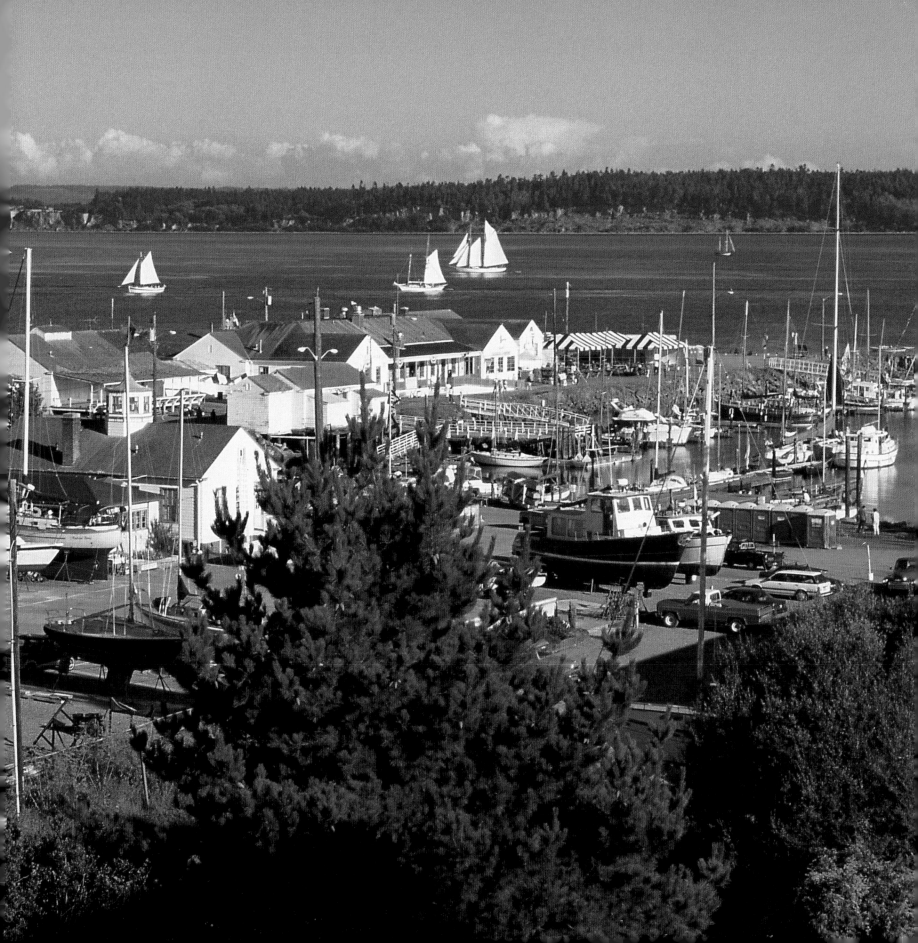

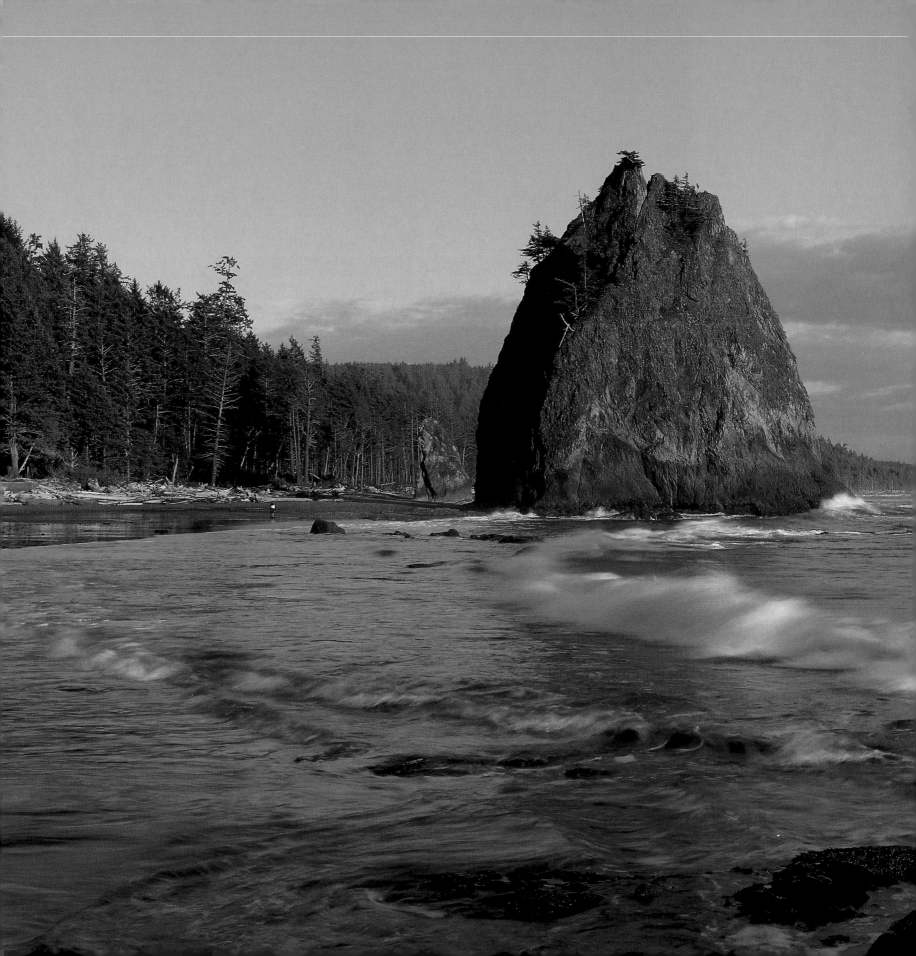

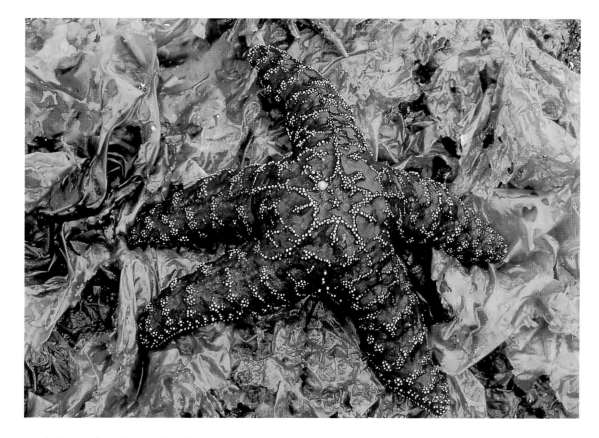

Tidal pools along the beaches shelter vibrant orange and purple sea stars. About 90 species of sea stars can be found in the Pacific Northwest.

Vehicle access is limited to protect the coastline, but hikers can discover some of Olympic National Park's best scenery along the shore. Sea stacks and tidal pools, piles of driftwood and occasional glimpses of migrating whales reward visitors.

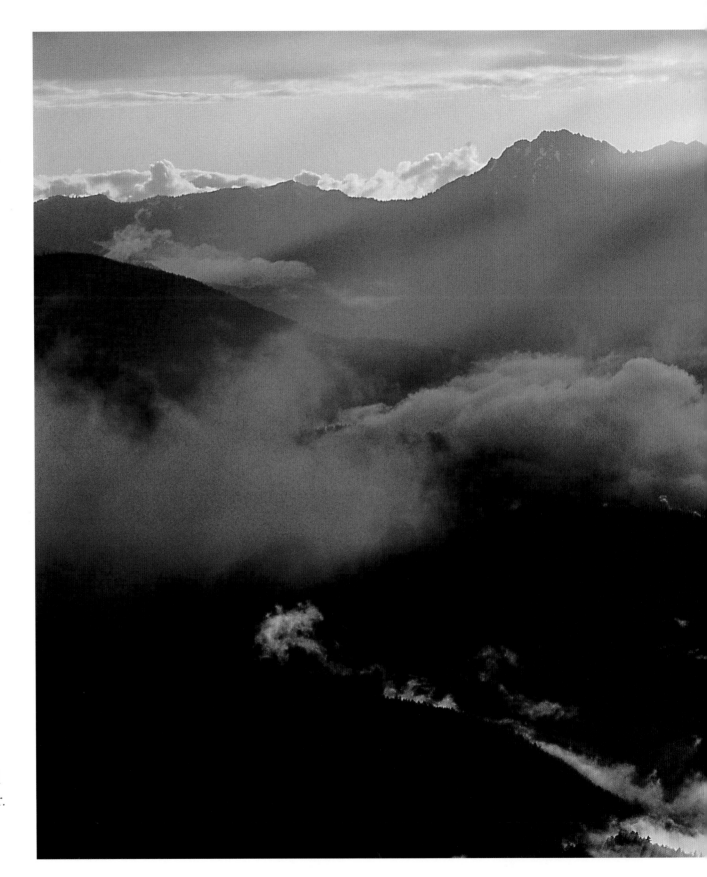

At 5,200 feet, Hurricane Ridge is one of the most awe-inspiring destinations on the Olympic Peninsula. The ridge is a popular hiking base in summer and a ski destination in winter.

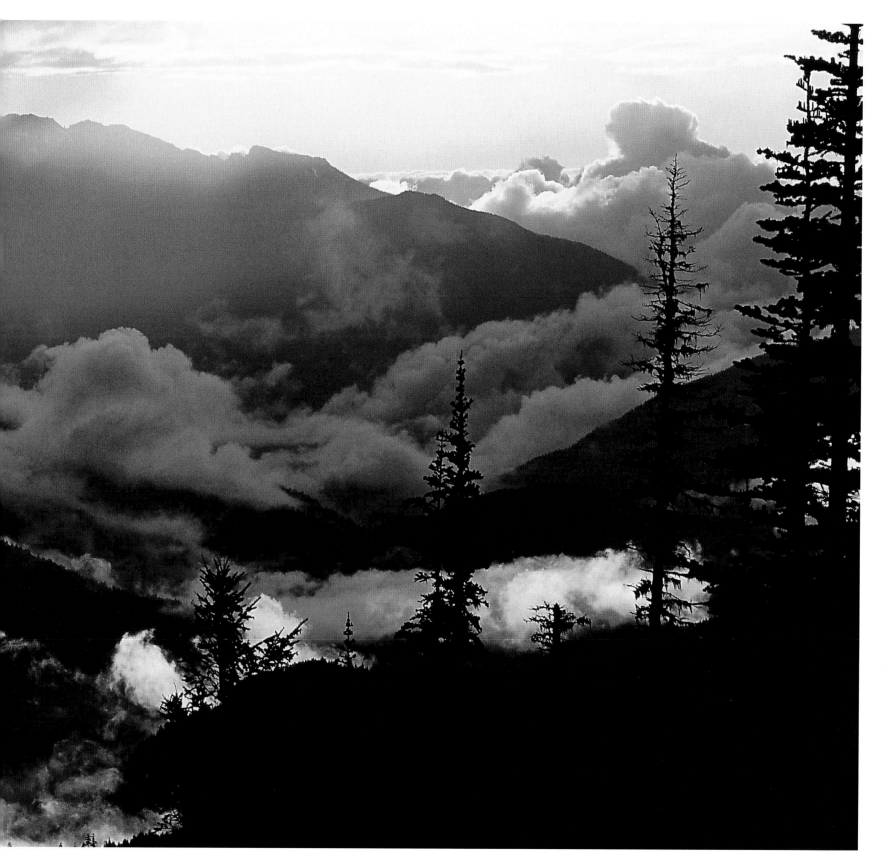

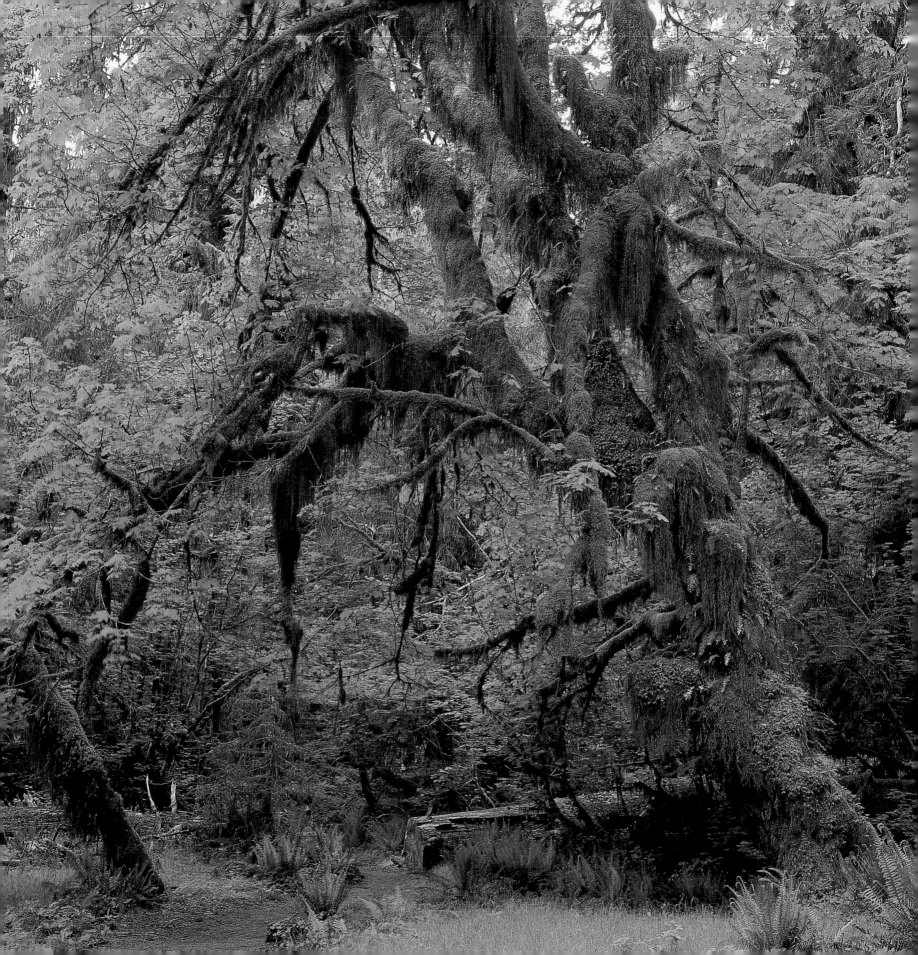

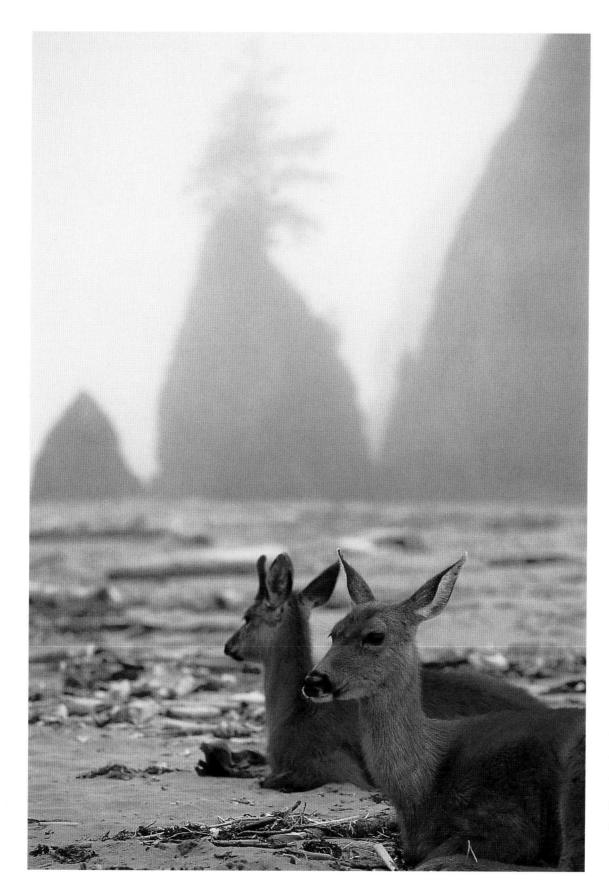

Olympic National Park boasts 58 miles of pristine coastline and a total area of 908,720 acres. The United Nations has declared it a World Heritage Site.

OPPOSITE —
The Hoh Rainforest is home to an unbelievable number of mosses and lichens — over 70 species. There are more than 300 plant varieties here, along with 180 bird species and about 50 kinds of mammals.

33

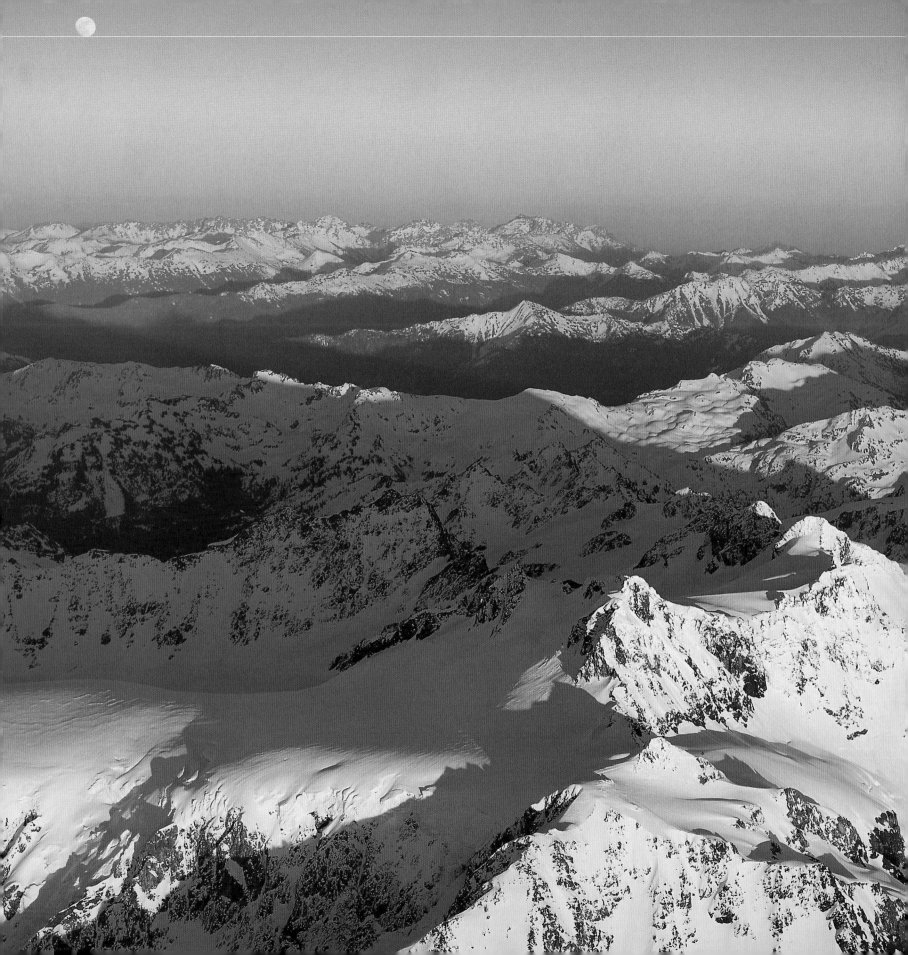

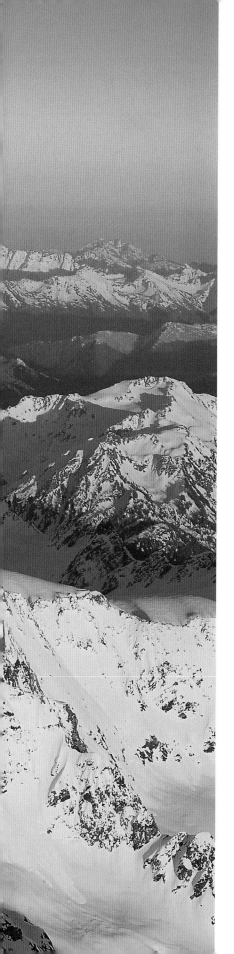

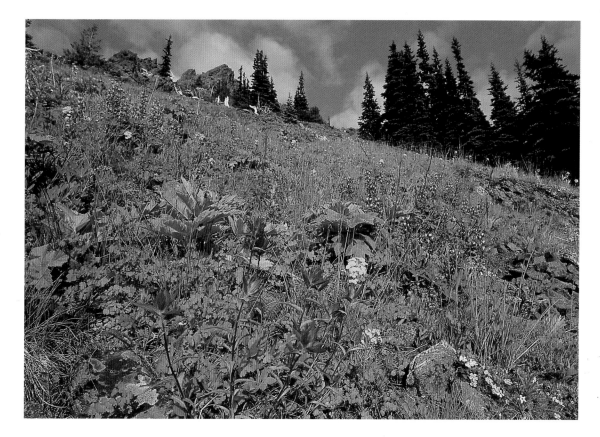

Wildflowers blanket the floors of the Quinault, Queets, and Hoh rainforests. Some of these flowers grow nowhere else. The forests are also home to the largest variety of mushrooms in the country.

Mount Olympus rises 7,965 feet, a height that inspired Captain John Meares to name it after the home of the gods in 1788. Hopefully, the gods don't mind getting a bit damp. With 200 inches of rain per year, this is the wettest peak in the continental United States.

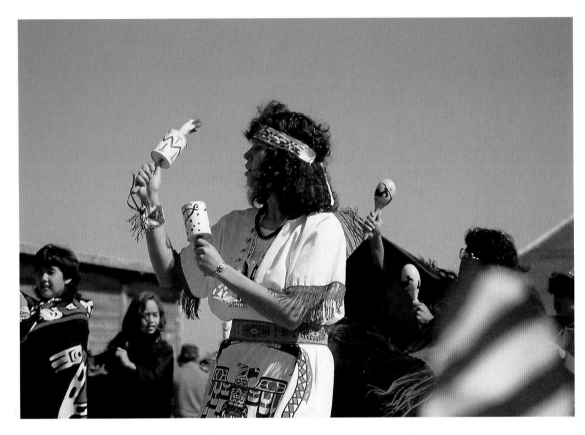

A rebirth of the arts and culture of native peoples is evident along the Pacific Coast, as elders strive to pass on traditional ceremonies and customs.

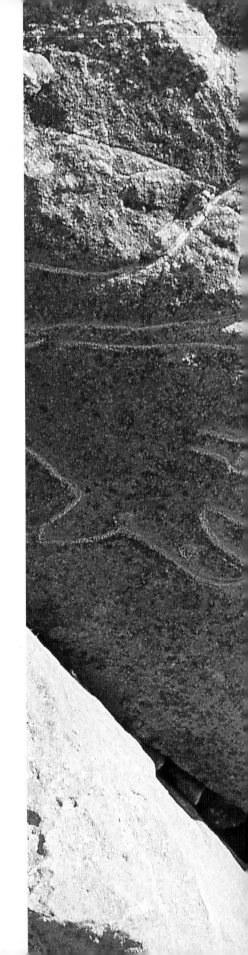

Petroglyphs offer visitors a glimpse of the past at Wedding Rock in Olympic National Park.

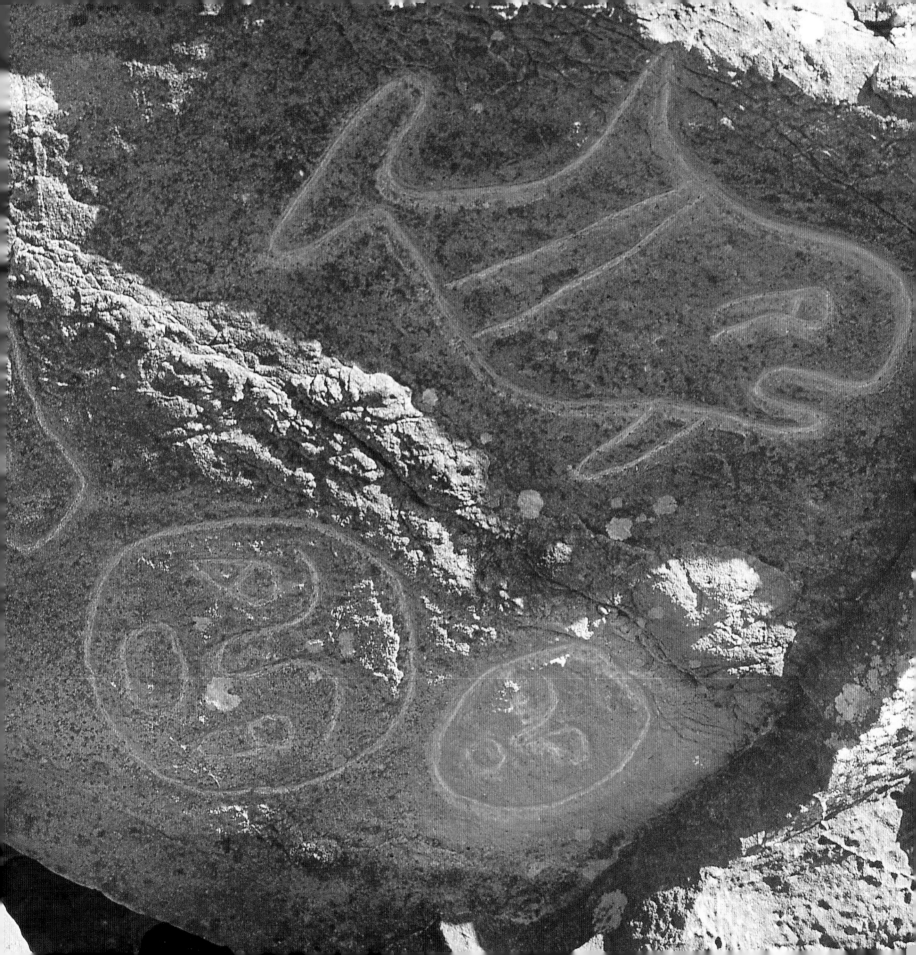

Chief Seattle is said to have met George Vancouver. His elaborate grave is just across Puget Sound from the city that bears his name.

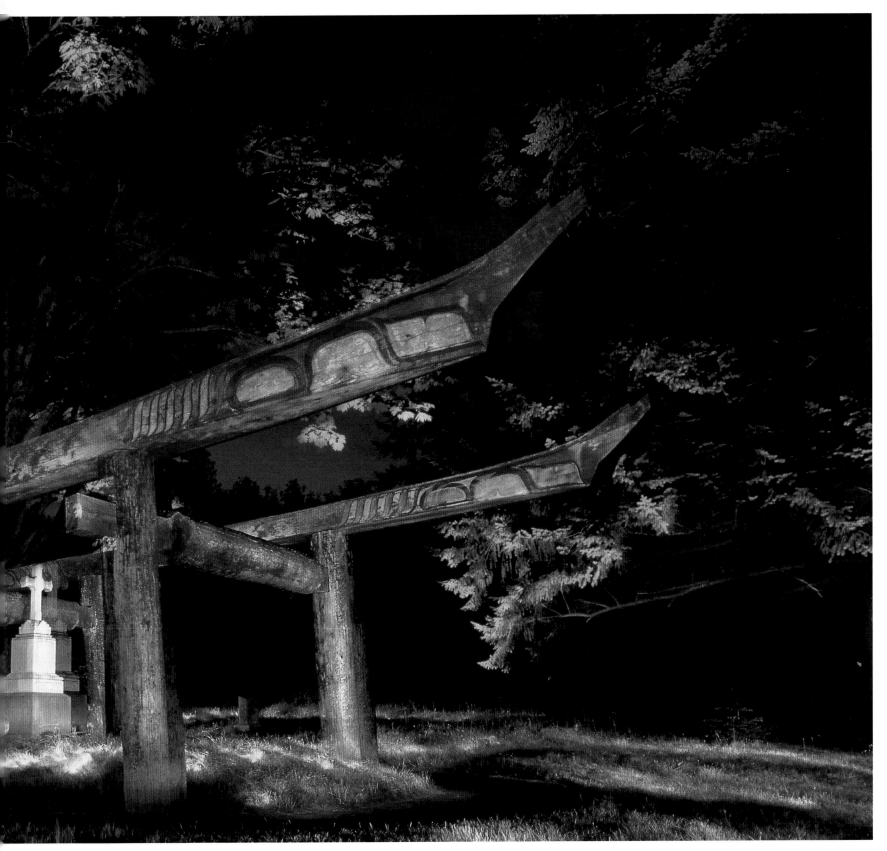

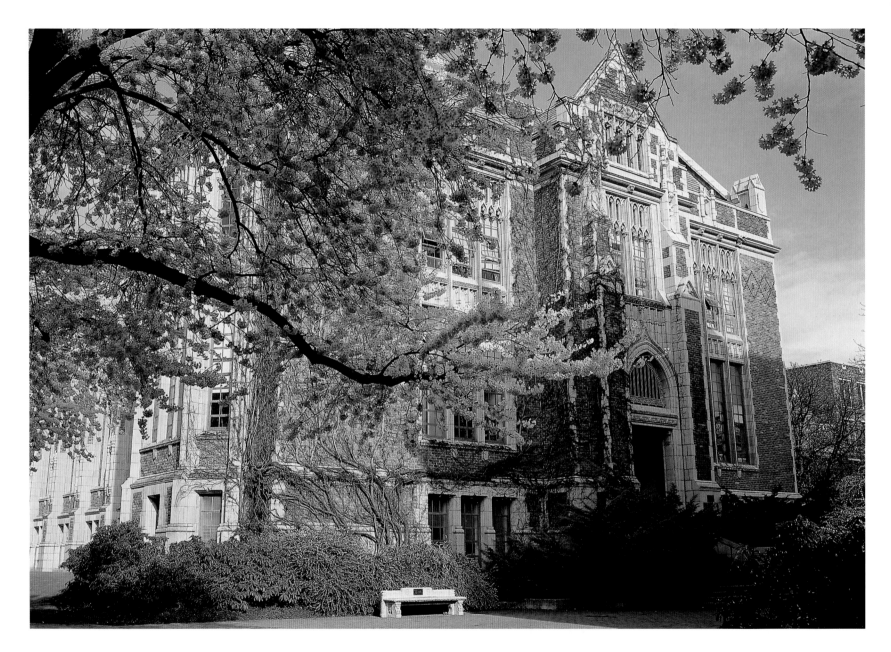

Opened in 1861, the University of Washington has grown
to include three campuses in Seattle, Bothell, and Tacoma.
About 35,000 students attend classes at the three locations.

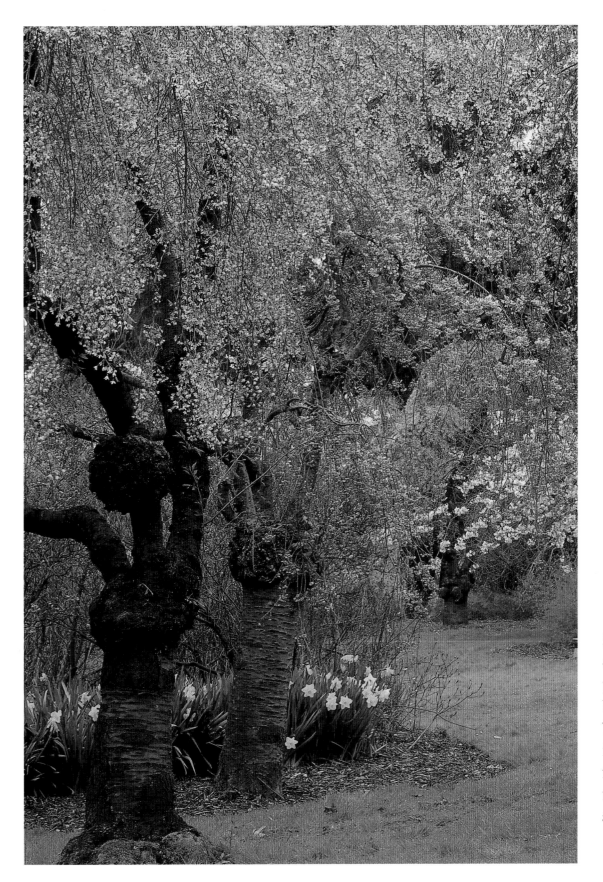

Spring blossoms fall over the meandering paths of Washington Park Arboretum. The quiet retreat features 5,000 plants, including native rhododendrons and dogwoods.

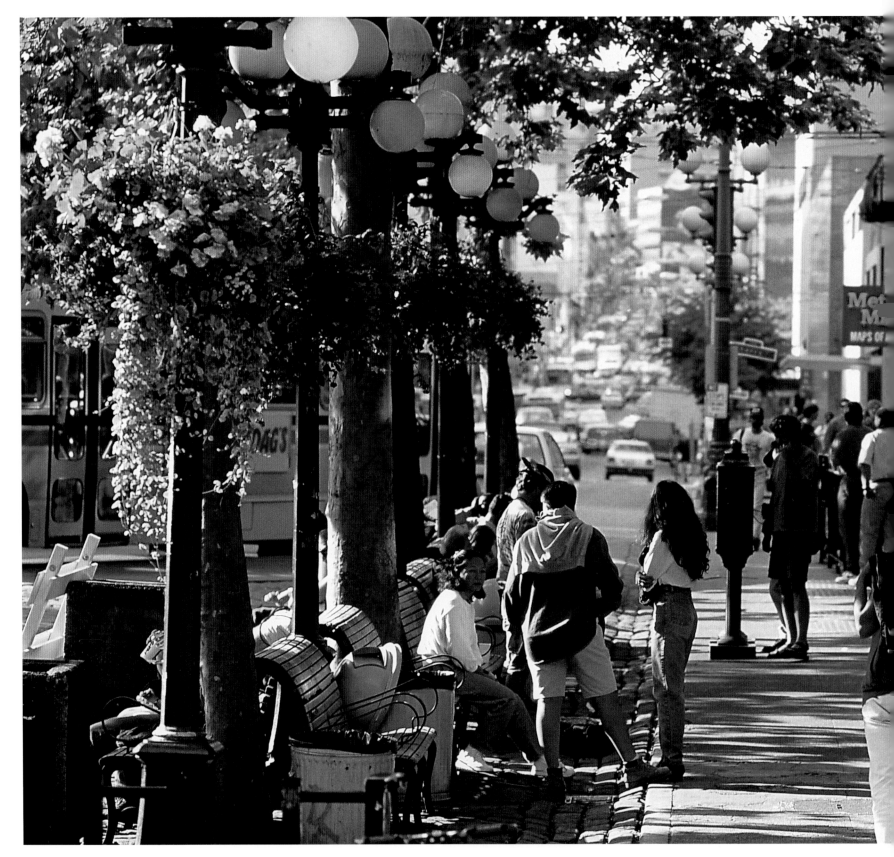

There are two levels to Pioneer Square — literally. Today's boutiques and restaurants were built above the city's early business district, much of which was destroyed in the Great Fire of 1889. Visitors can now descend beneath the square on tours of the Underground City.

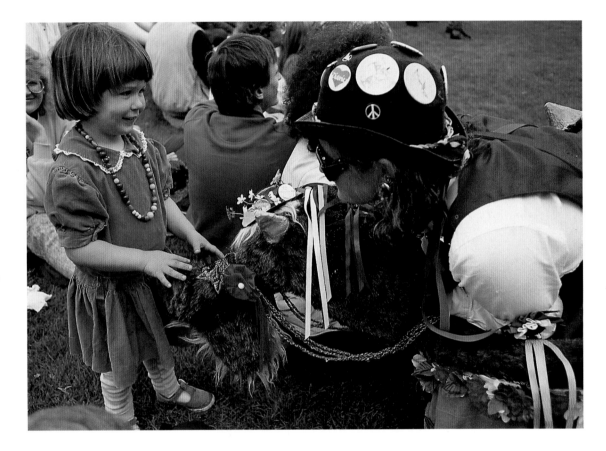

A morris dancer performs at Seattle's Northwest Folklife
Festival, the largest celebration of its kind in America.
The festival is held annually on Memorial Day weekend.

Seattle's Pike Place Market was founded in 1907. In the
1960s, the market seemed doomed, as developments
were planned for the area. Public concern resulted
in the rejuvenation of the buildings and the creation
of Pike Place Market National Historic District.

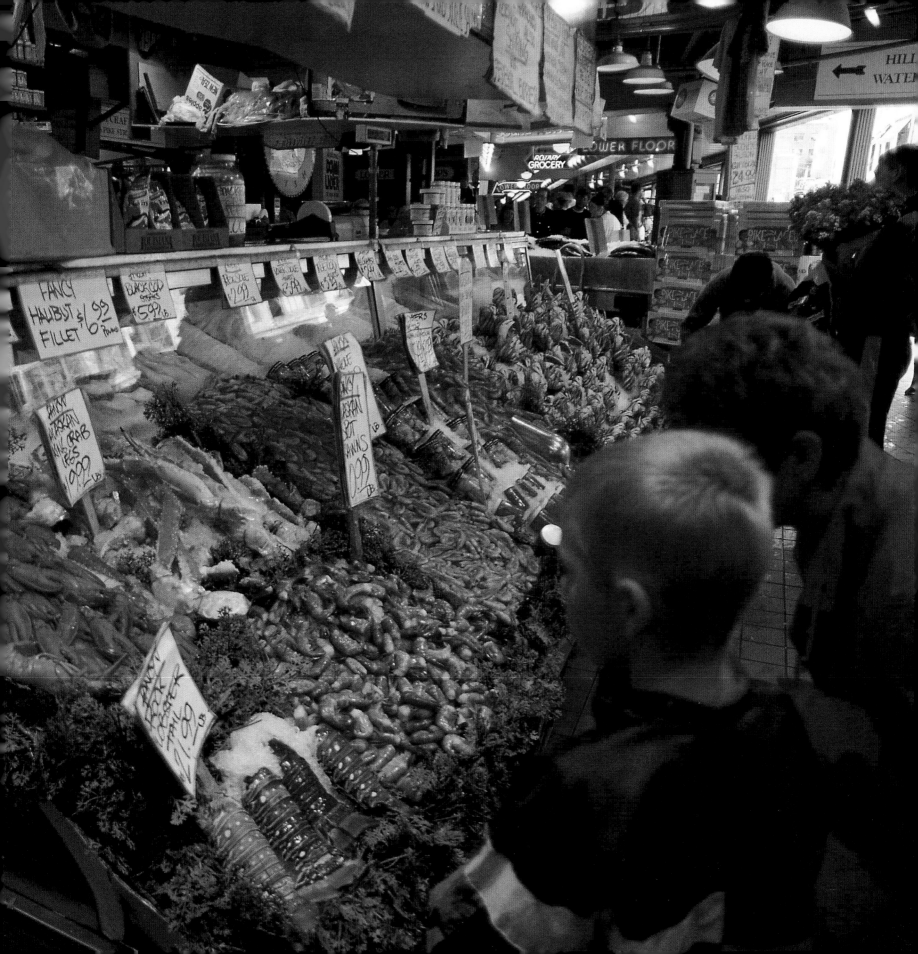

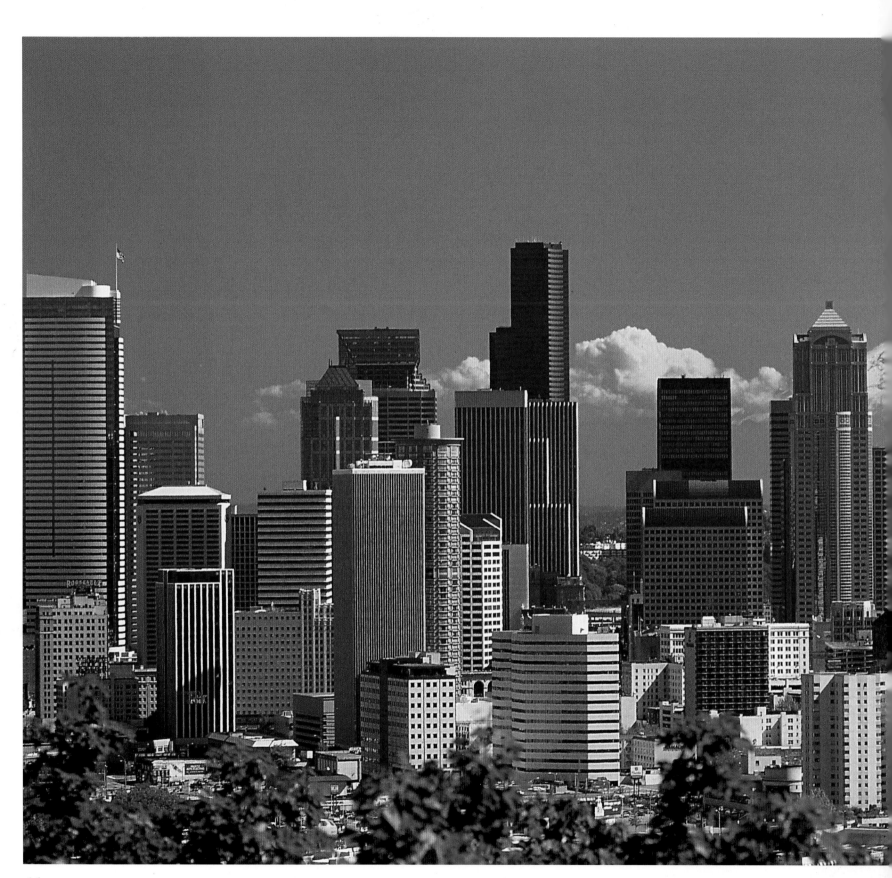

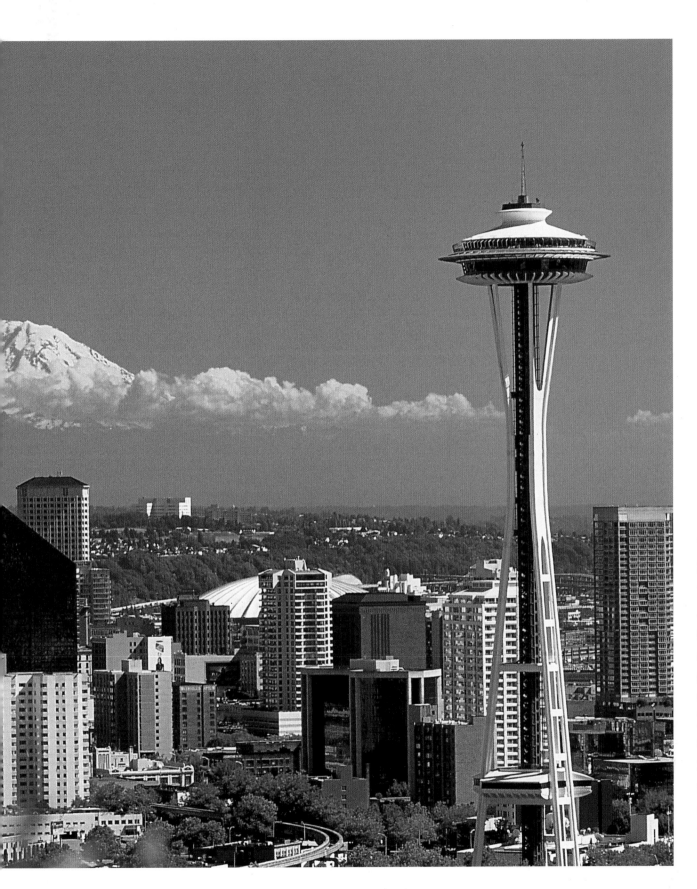

The elevators of the Seattle Space Needle will whisk you up 518 feet in less than a minute. If the trip doesn't make your stomach churn, the Space Needle Restaurant offers elegant dining as it slowly rotates, allowing a 360-degree view of the city.

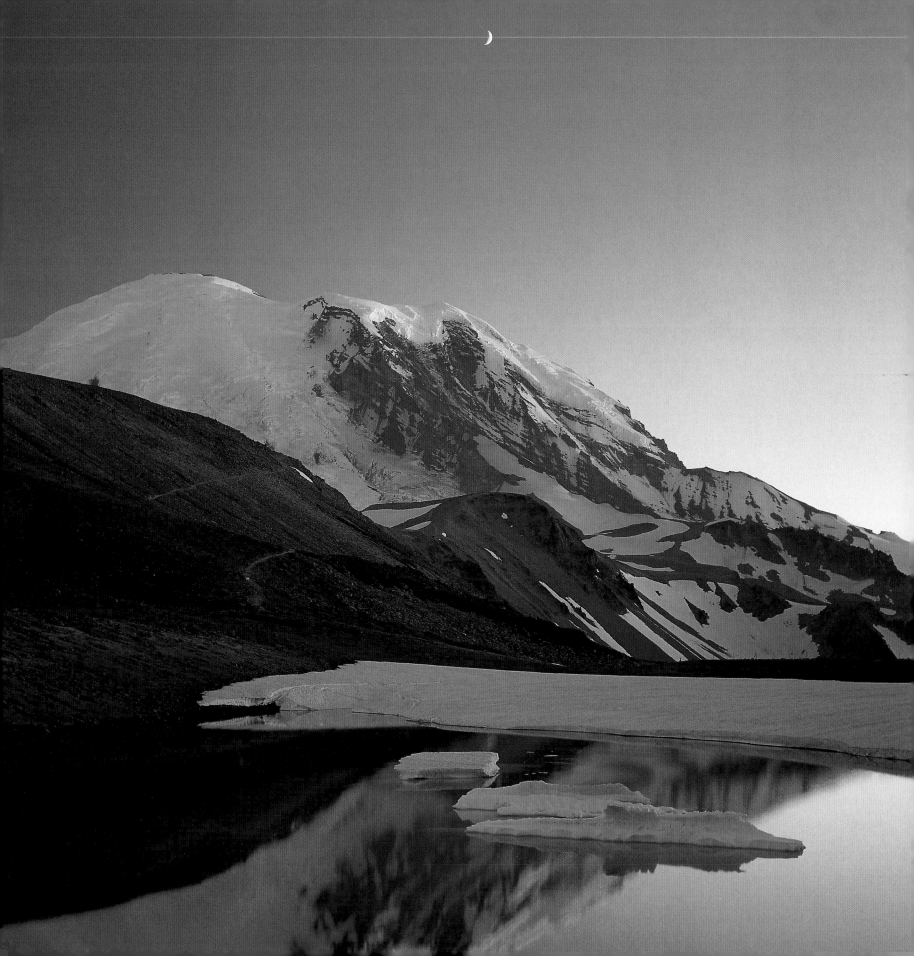

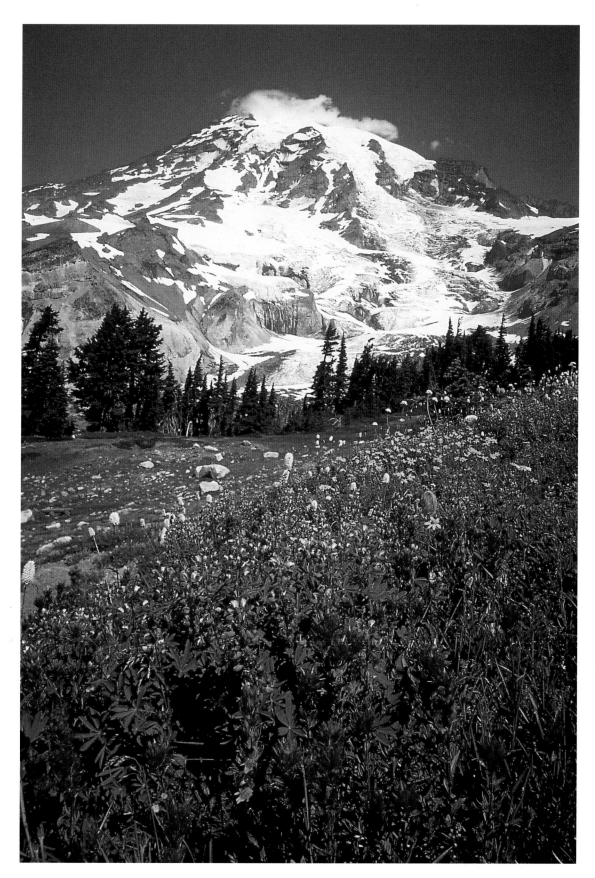

Wildflowers carpet Mount Rainier, from the forest floor at the base to the edge of the icefields. Two climbers—Stevens and Van Trump—hiked these slopes to the summit in 1870. Now, the meadows provide a welcome resting spot for more than 3,000 climbers who set out to the summit each year.

OPPOSITE —
The highest volcanic peak in the Cascade Ranges, Mount Rainier reaches 14,410 feet above sea level. It is capped by some of the largest glaciers on the continent.

The 187-foot
Romanesque dome
of Olympia's
Legislative Buildings
was once one of the
largest in the world.
The buildings are
surrounded by
lush gardens,
fountains, and
historic buildings.

OPPOSITE—
About 6,000 feet
long, the Narrows
Bridge in Tacoma
connects the city
with the Olympic
Peninsula. The first
bridge in this
location collapsed
due to high winds
in 1940.

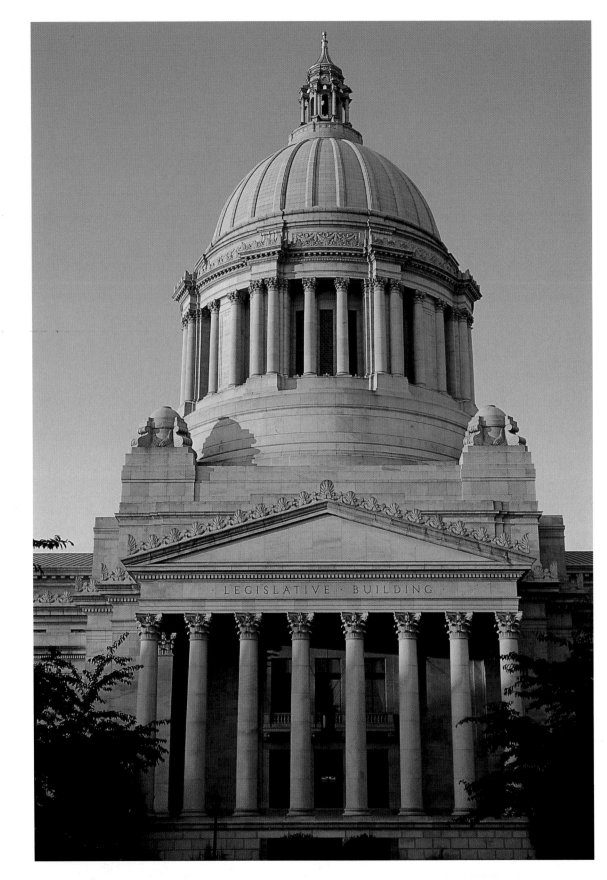

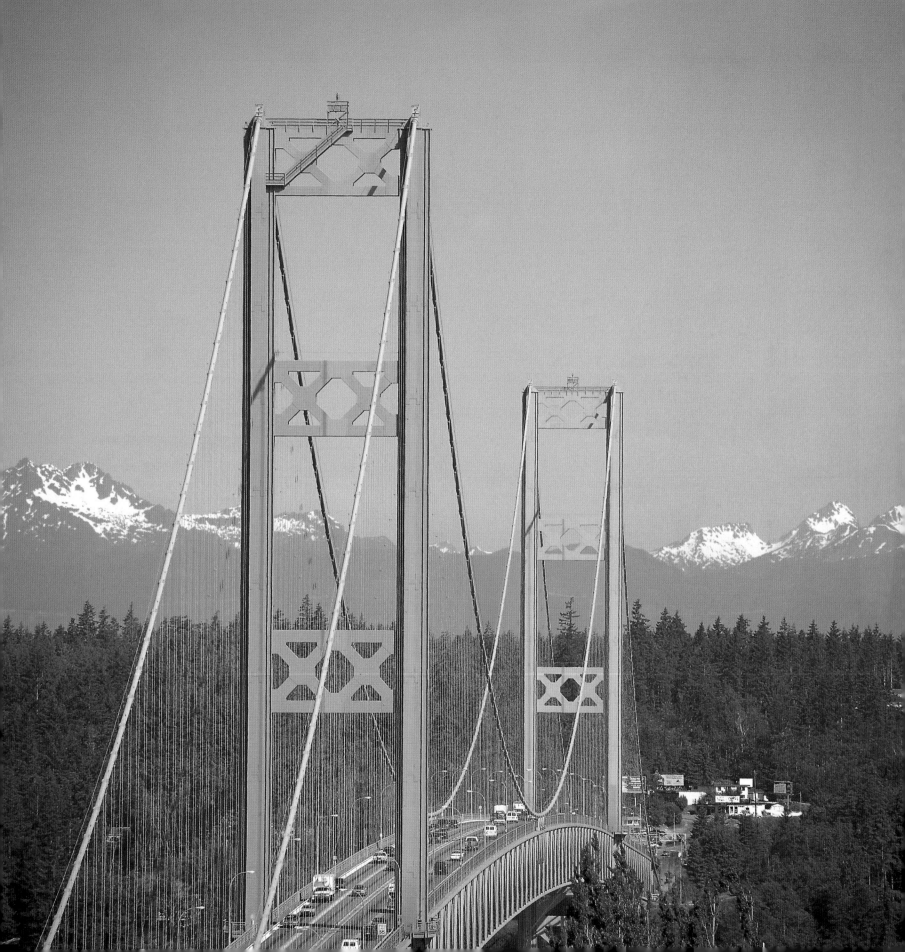

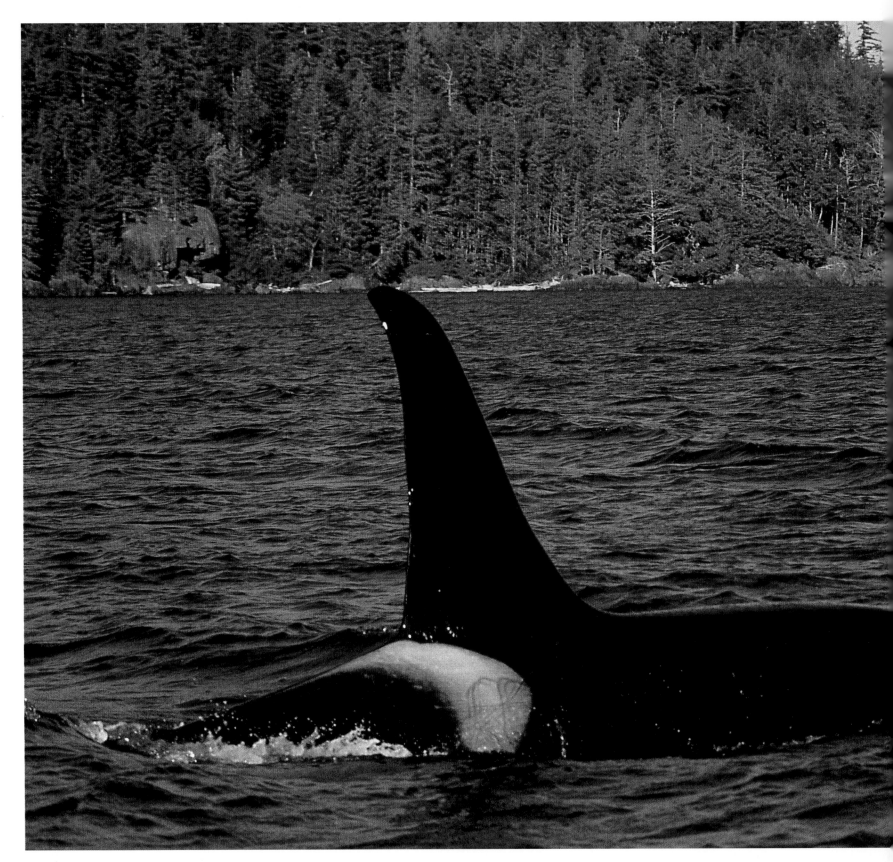

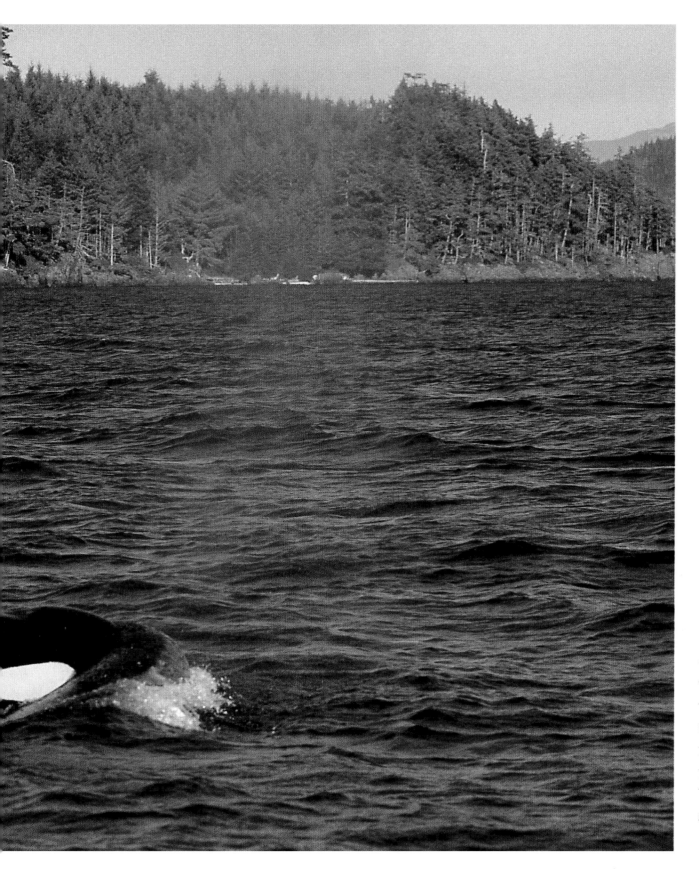

Orcas, or killer whales, are often willing to swim close to shore, or even into populated bays, in pursuit of prey. They're a common sight along the coast.

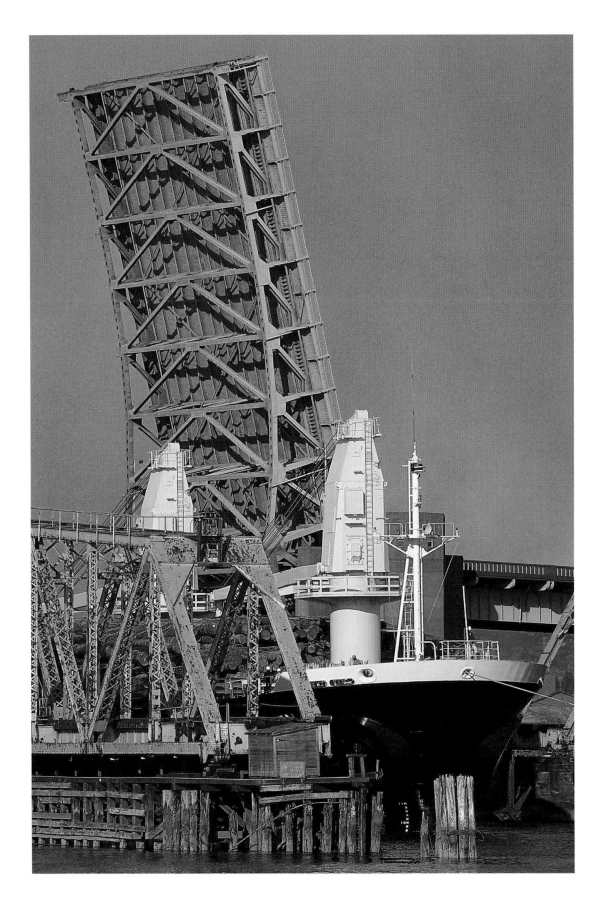

Aberdeen has a long history as a port and a commercial fishing center. The small community sits at the eastern edge of Grays Harbor, the deepest harbor on the Washington coast.

54

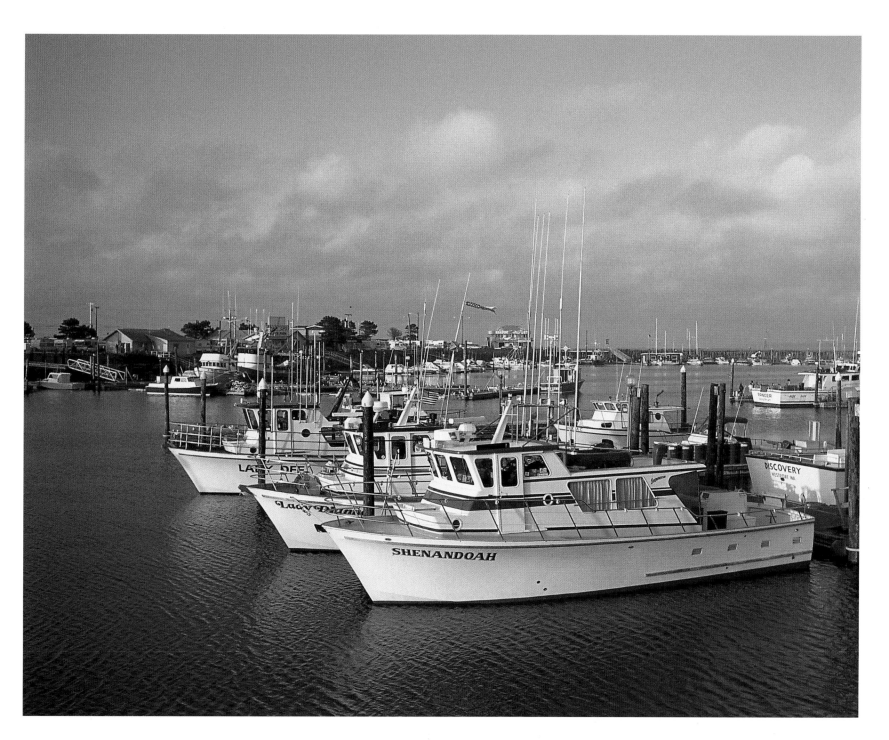

With a commercial fleet docked in the harbor, charters ready for sport fishers, a maritime museum, and an aquarium, Westport is first and foremost a fishing community.

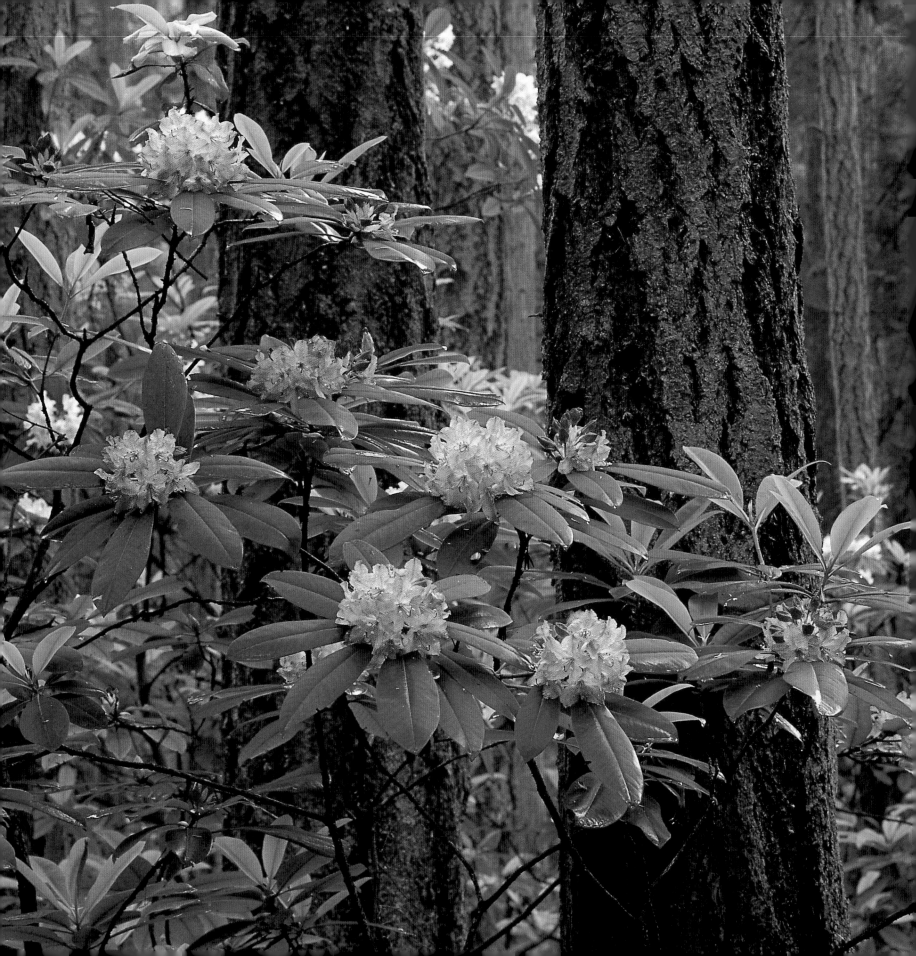

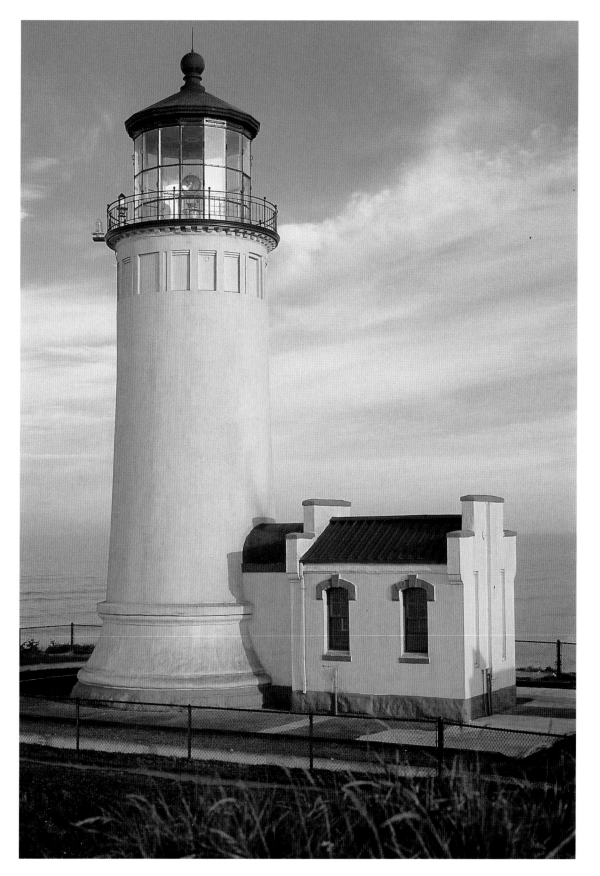

The North Head Lighthouse was built in 1899 to help warn sailors of the dangers at the mouth of the Columbia River. Hundreds of ships have gone down here, victims of the currents, swells, and hidden sandbars that have earned the area the title of "graveyard of the Pacific."

OPPOSITE —
The rhododendron is Washington's state flower. With blooms up to six inches across, this well-known shrub grows throughout the coastal forests.

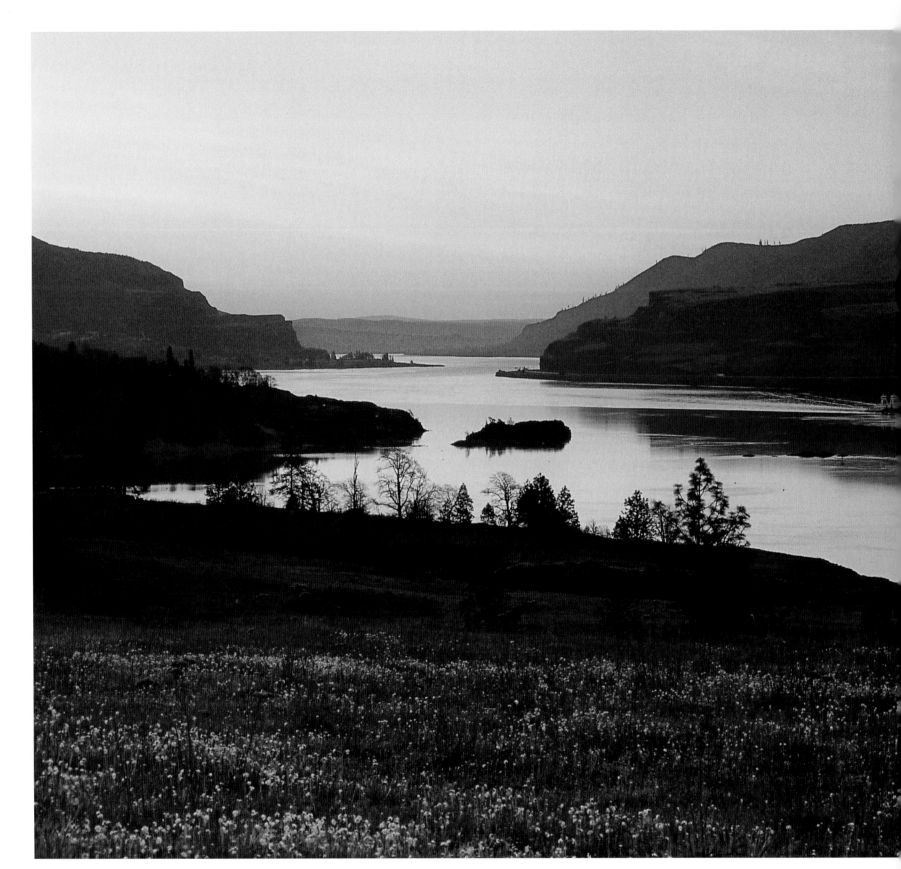

The Columbia River
journeys more than
1,200 miles from the
Canadian Rockies to
the Pacific. Draining
Washington, Oregon,
Idaho, and much
of British Columbia,
it is the largest river
on the continent
to empty into
the Pacific.

Dog Mountain is one of the popular hiking destinations in the Columbia River Gorge area. Both sides of the gorge are protected as a national scenic area that encompasses almost 300,000 acres.

OPPOSITE—
Mount Saint Helens is surrounded by evidence of the mountain's eruption on May 18, 1980, which blasted a crater two miles long. The explosion killed 65 people and destroyed 160,000 acres of forest. This is now the world's most studied volcano.

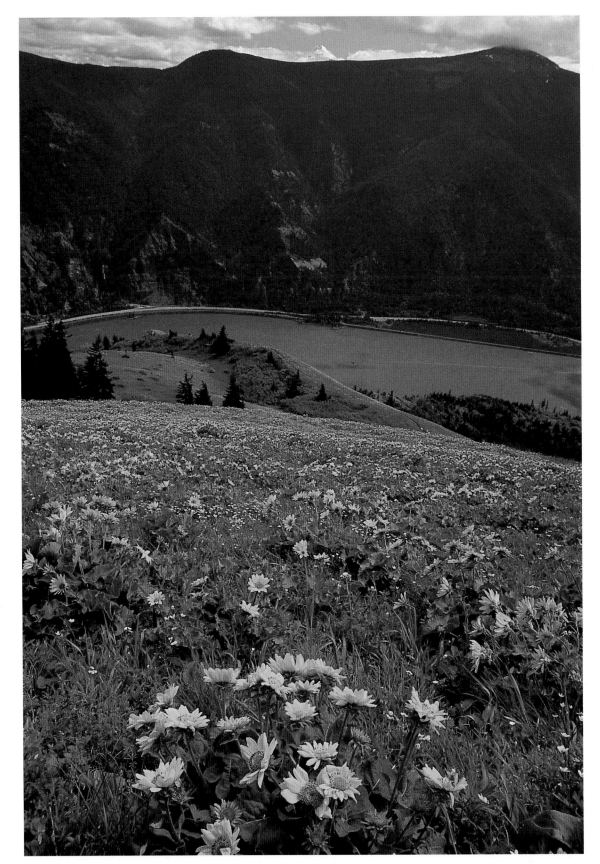

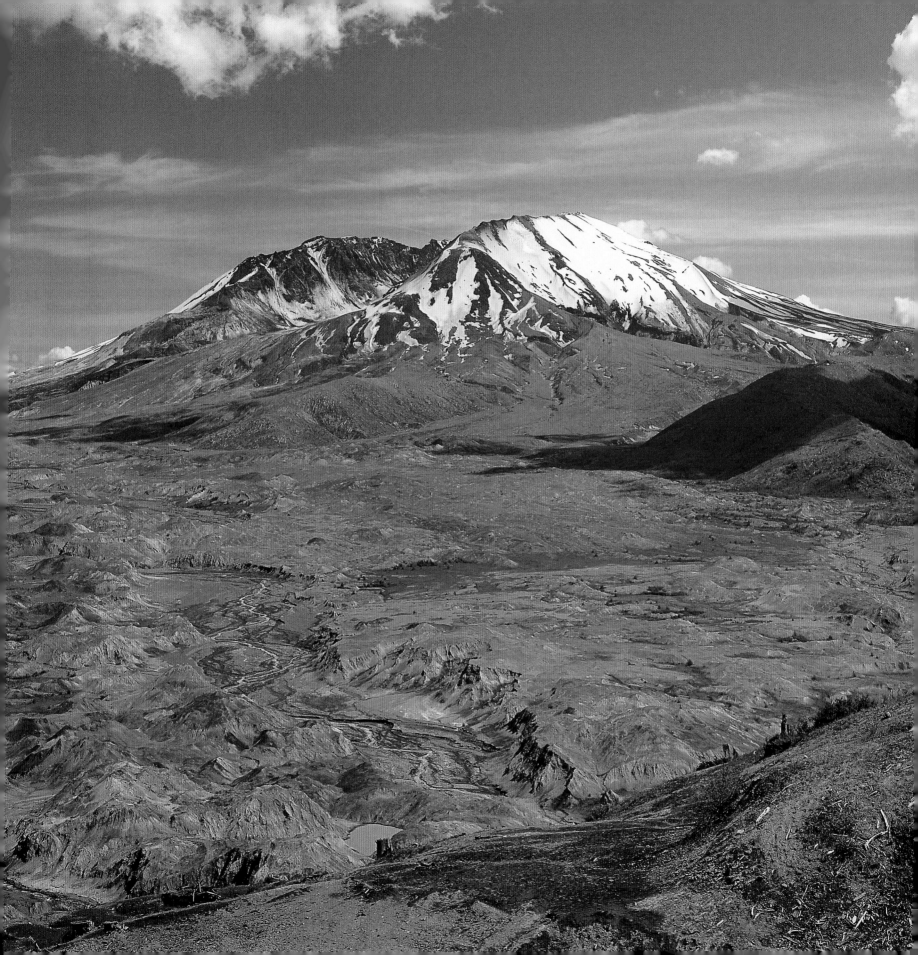

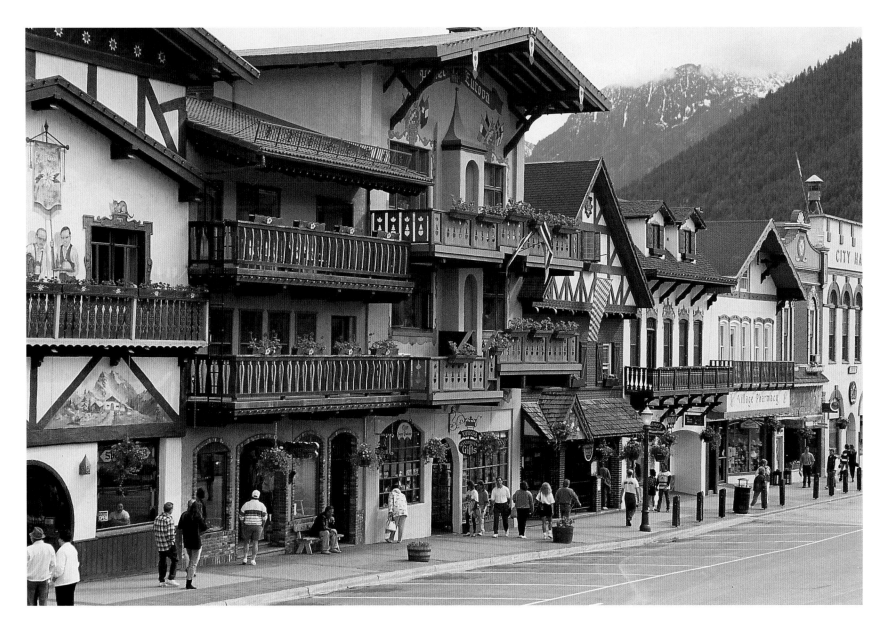

Leavenworth's Bavarian theme is part of an elaborate—and successful—attempt to attract visitors to the area. Faced with railway and mill closures in the mid-1900s, the town decided to capitalize on its mountain location. Now Leavenworth draws more than a million tourists a year.

An actor poses as a 19th-century fur trader at Fort Vancouver, once a central outpost of the Hudson's Bay Company.

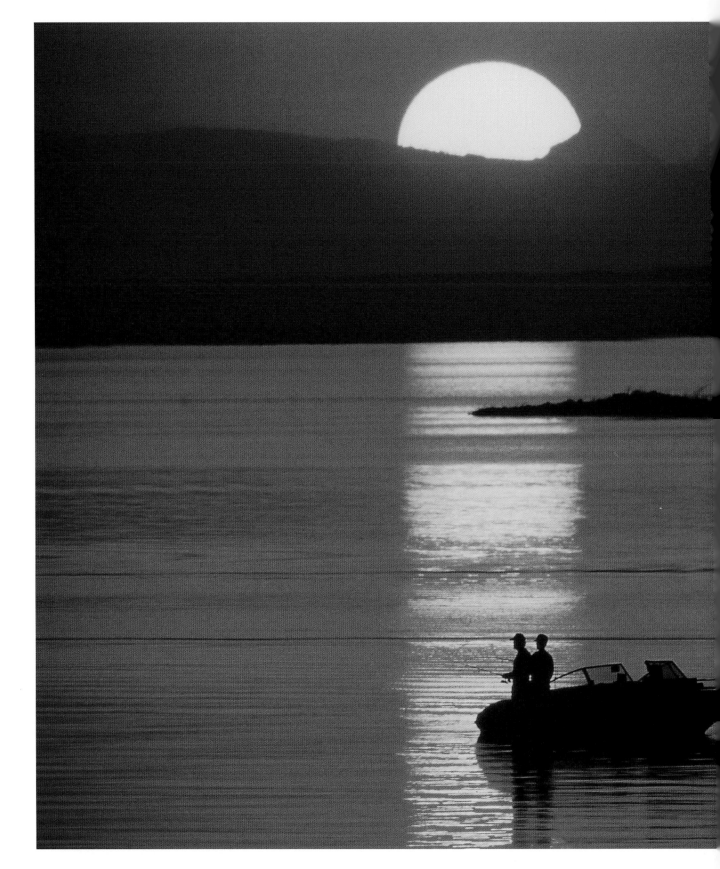

The remote location of Moses Lake in central Washington allows anglers to find a quiet moment on the water. Part of the Pacific flyway, the lake is visited by more than 200 species of migrating birds each year.

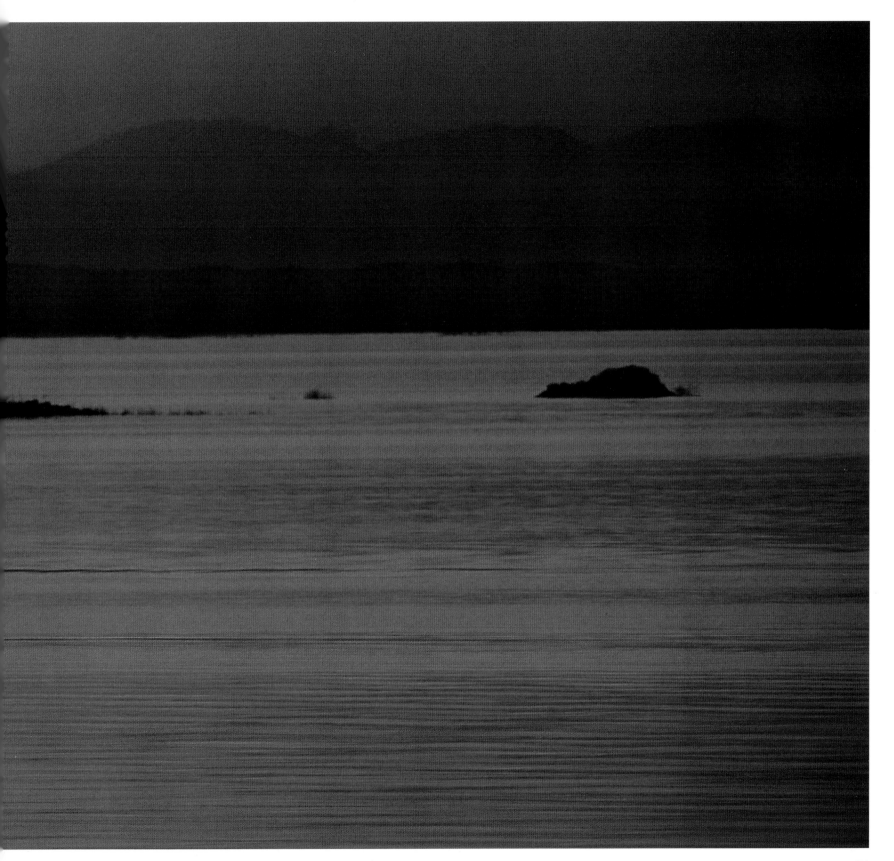

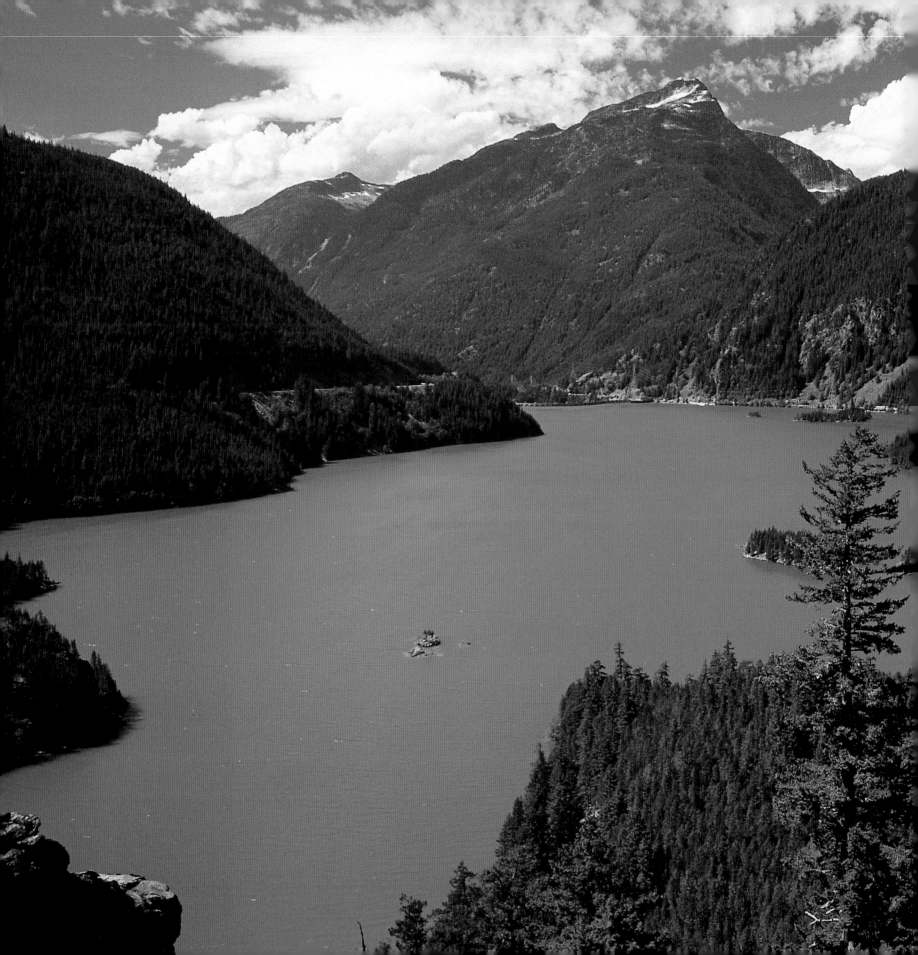

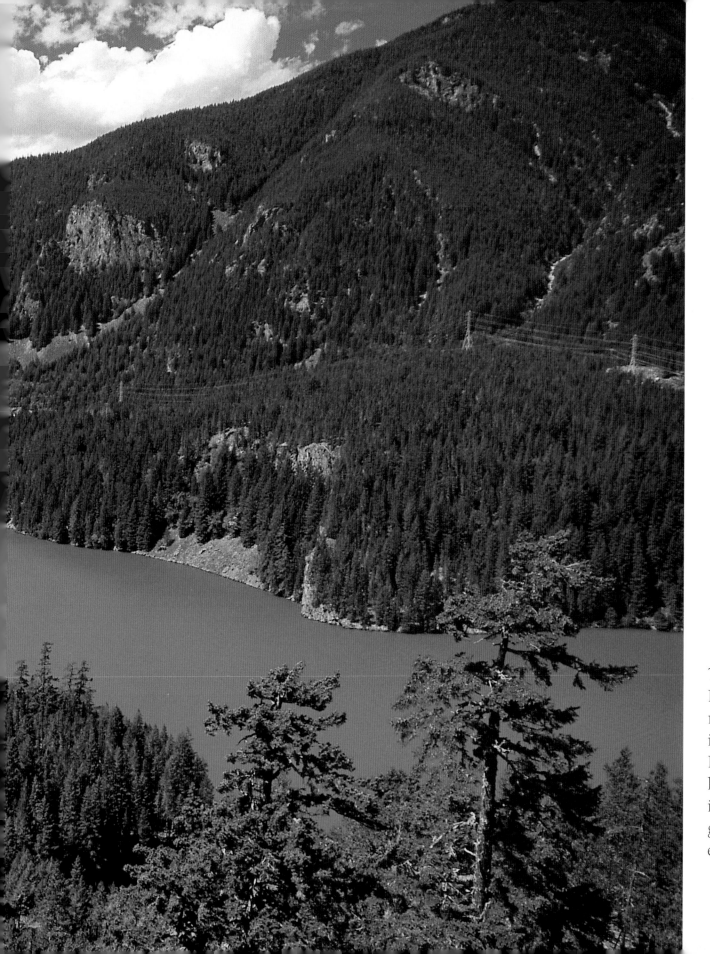

The glaciers above Diablo Lake grind rock and minerals into fine particles. It is those particles, hanging suspended in the water, that give the lake its emerald color.

67

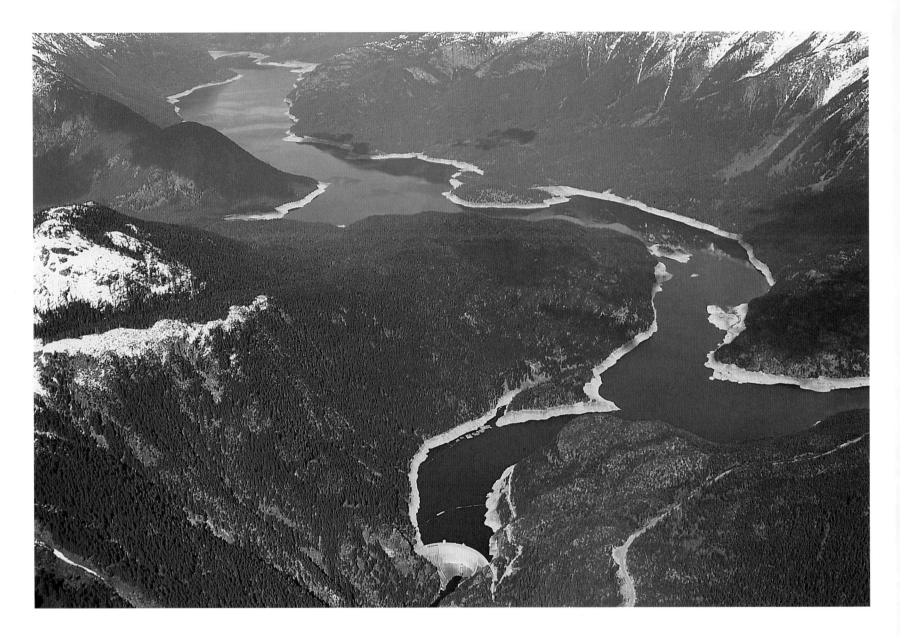

The construction of Ross Dam on the Skagit
River created 24-mile-long Ross Lake, which
reaches into Canada.

Black bears are common in the mountains
of Washington, where abundant habitat
allows them to roam freely. In a single year,
a bear may travel about 30 square miles
in search of food.

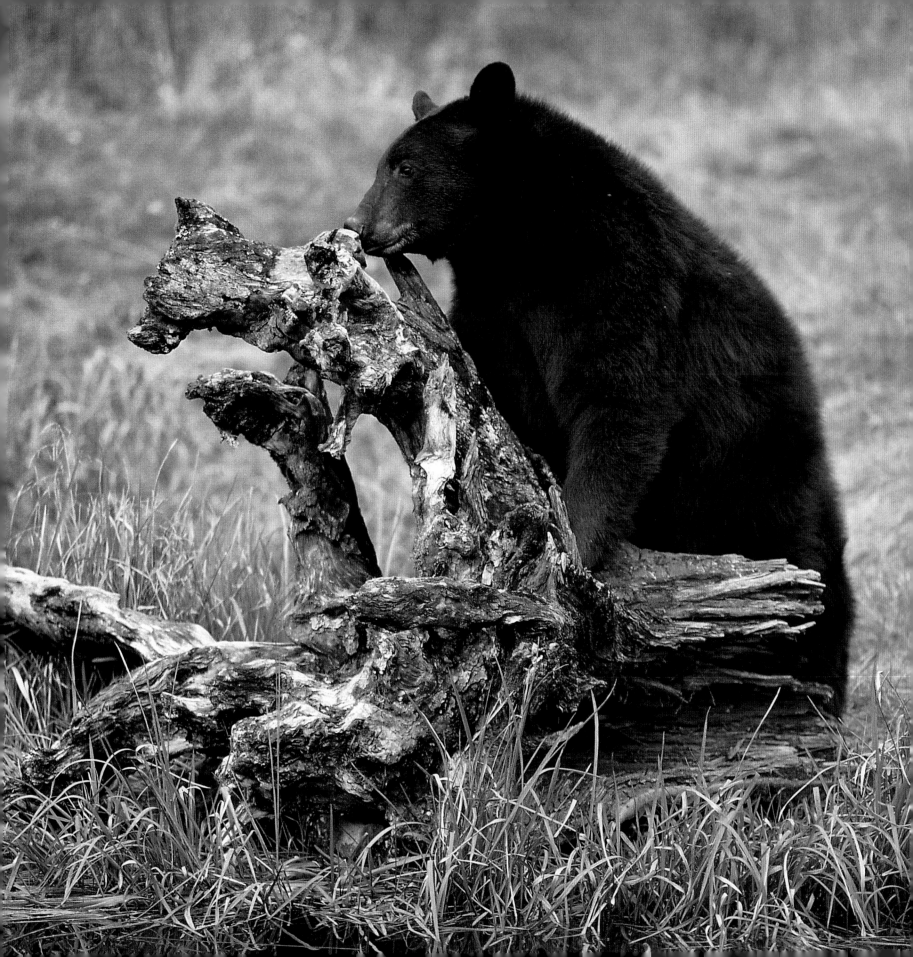

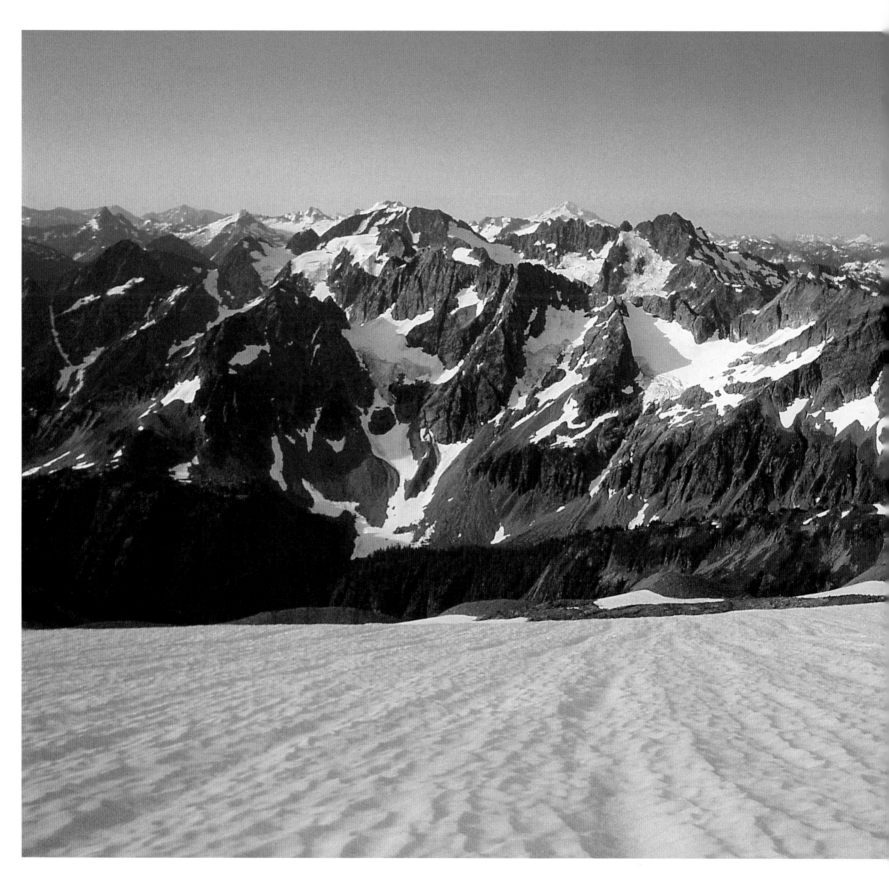

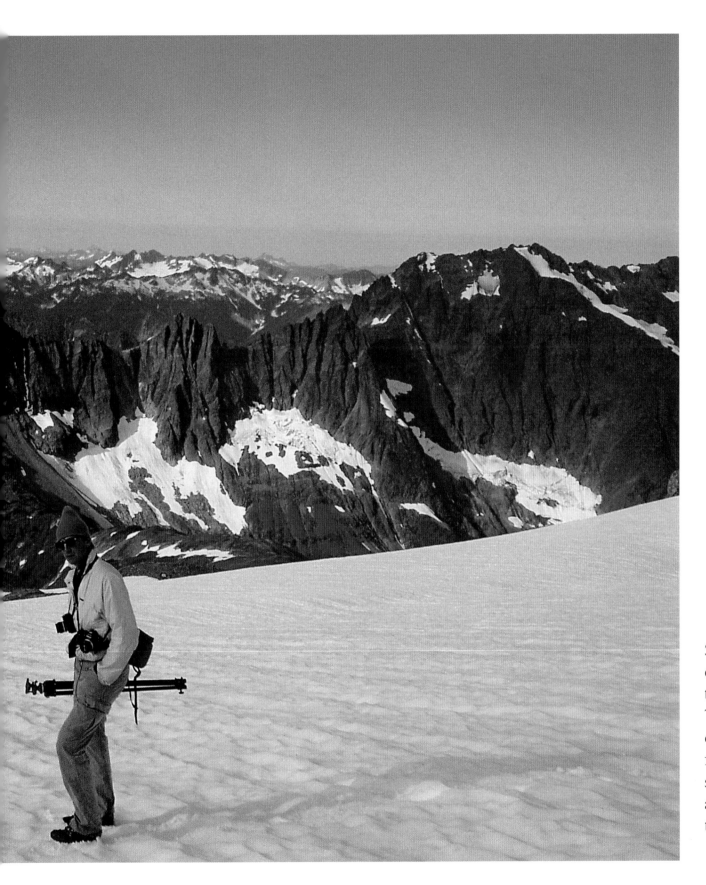

Sahale Glacier is one of about 300 in the North Cascades. These are some of the most remote mountains in the state and were among the last to be explored.

The name Picture Lake is appropriate—this view of the lake and Mount Shuksan is one of the most-photographed places in Washington. Reaching to 8,268 feet, the mountain often serves as a training ground for hikers and climbers.

OPPOSITE—
Nicknamed the American Alps, the Northern Cascade Range was protected in 1968 with the establishment of a national park. Through the efforts of the Sierra Club and the North Cascades Conservation Council, 504,780 acres were preserved. Nearby Ross Lake and Lake Chelan recreation areas protect an additional 180,000 acres.

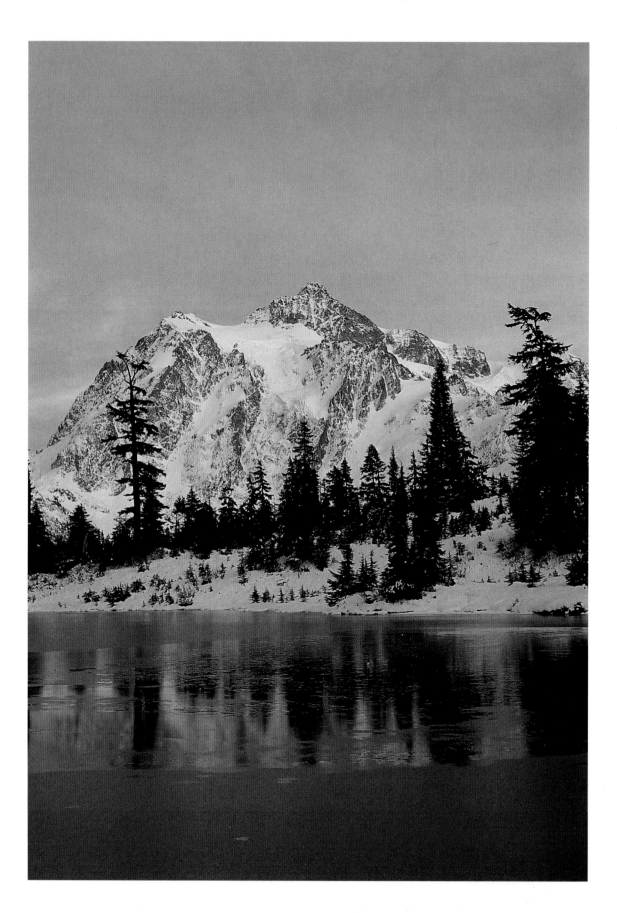

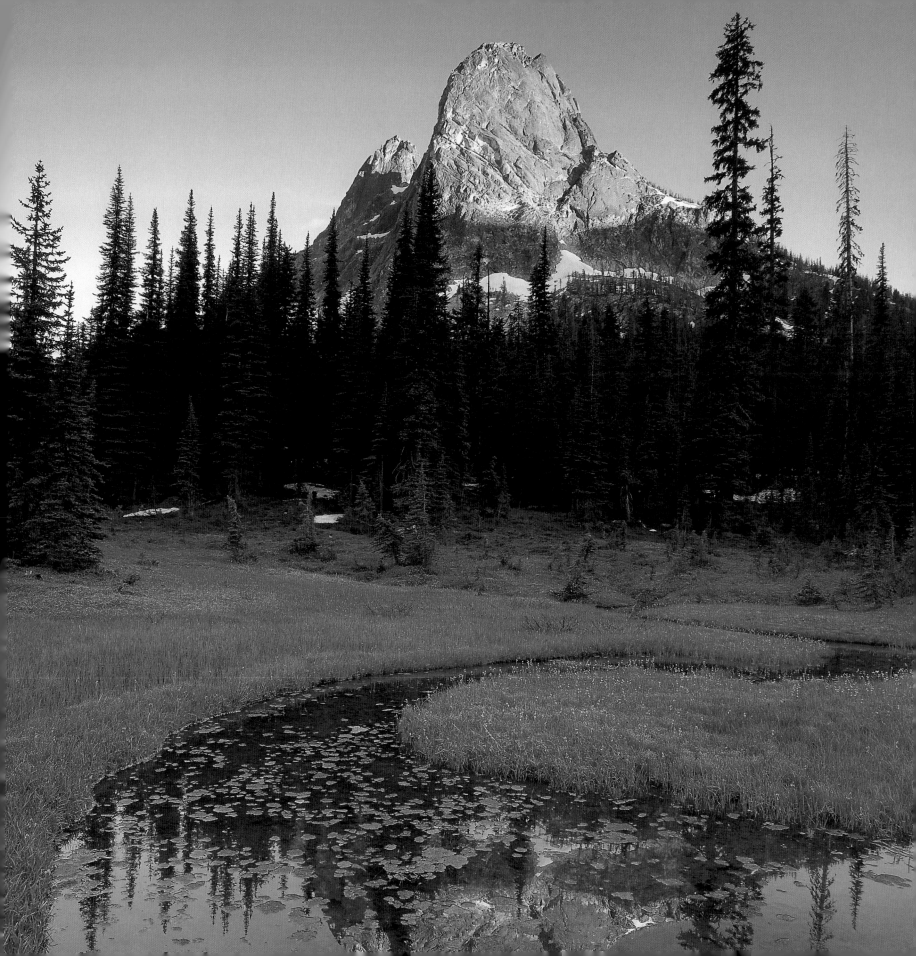

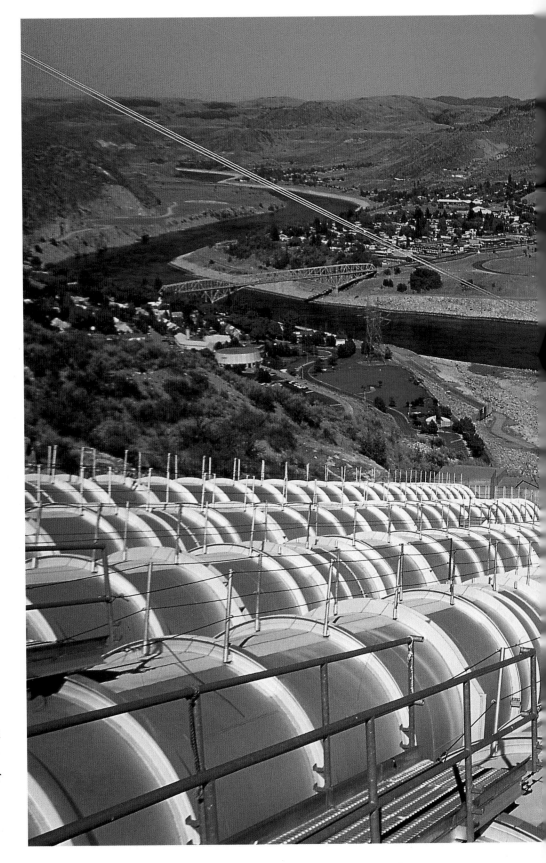

The Grand Coulee Dam is the largest concrete structure in the world and produces more energy than any other dam. It does so by harnessing the power of the Columbia River, creating Roosevelt Lake.

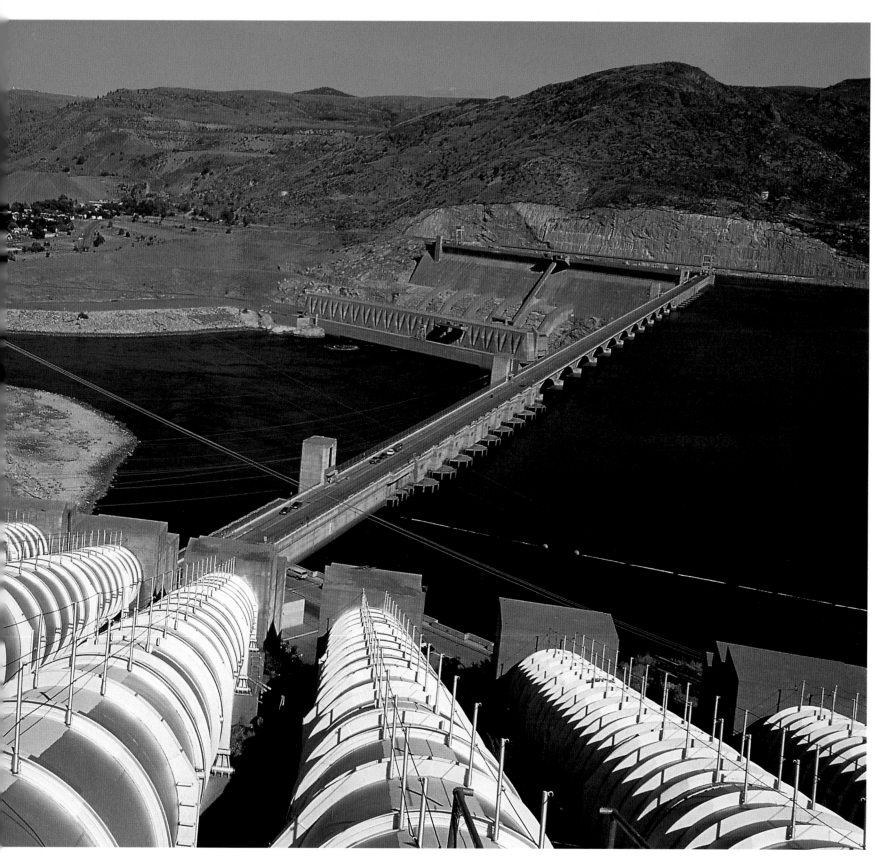

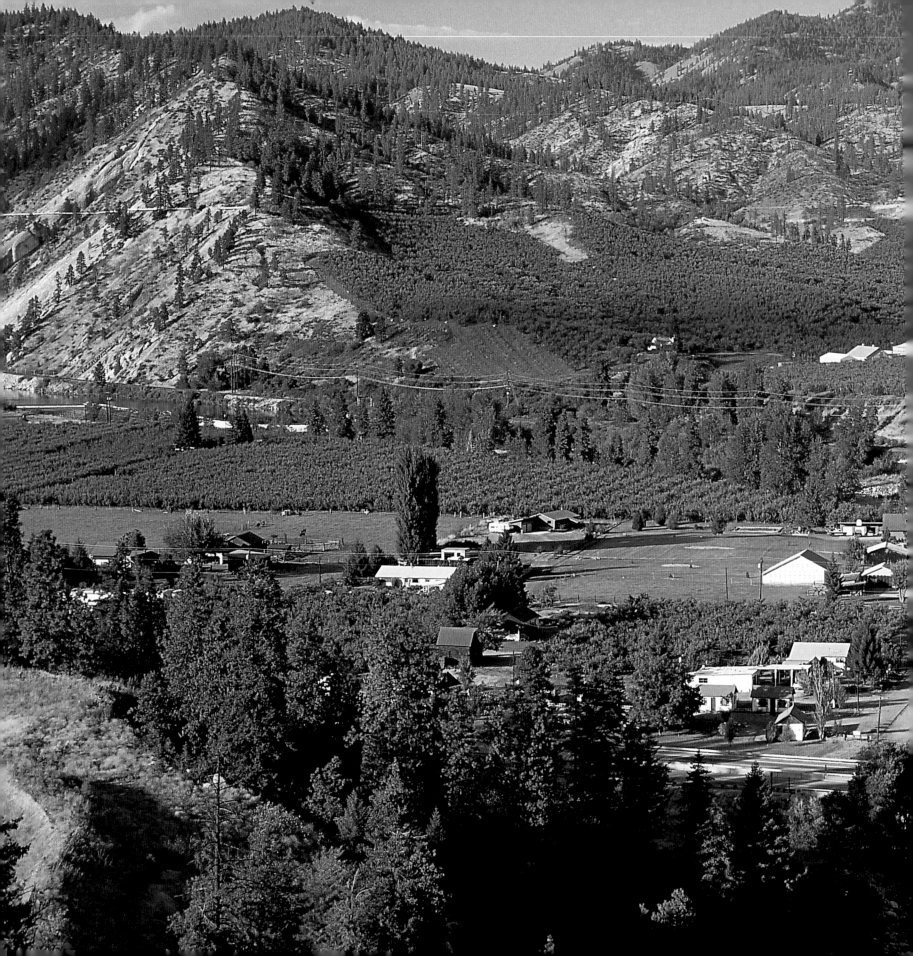

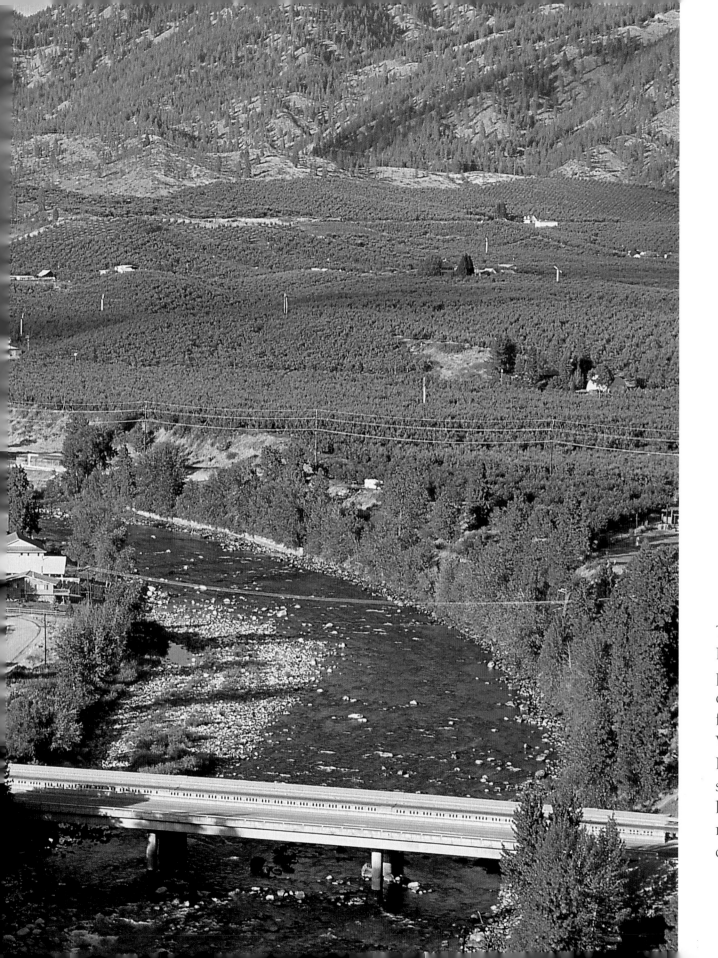

The Wenatchee River winds through picturesque apple orchards. Just a few miles away, Wenatchee National Forest offers thousands of miles of hiking trails and more than 60 campgrounds.

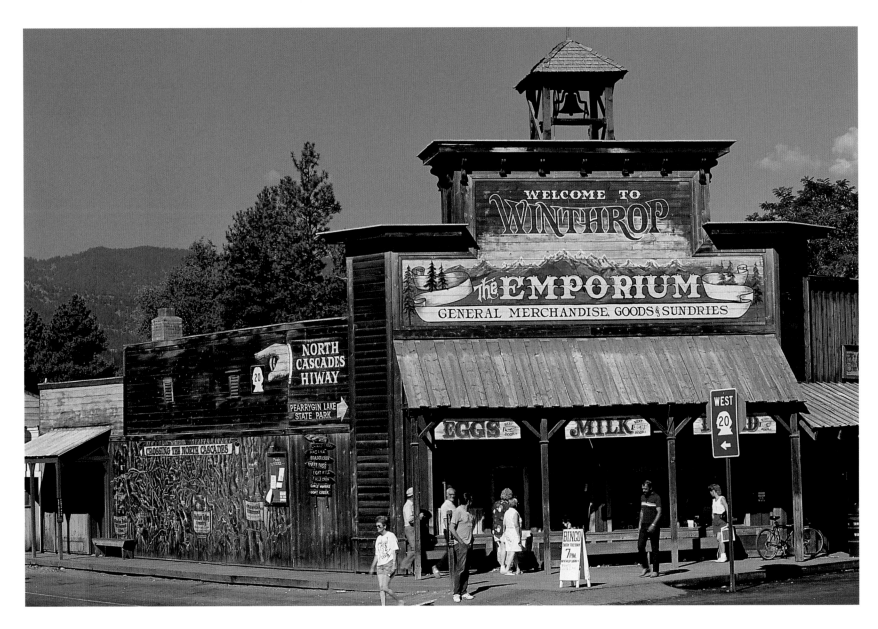

In Winthrop, you can tie your horse to a hitching post and saunter through the doors of a saloon. This Western-style town commemorates the pioneer days of the Methow Valley.

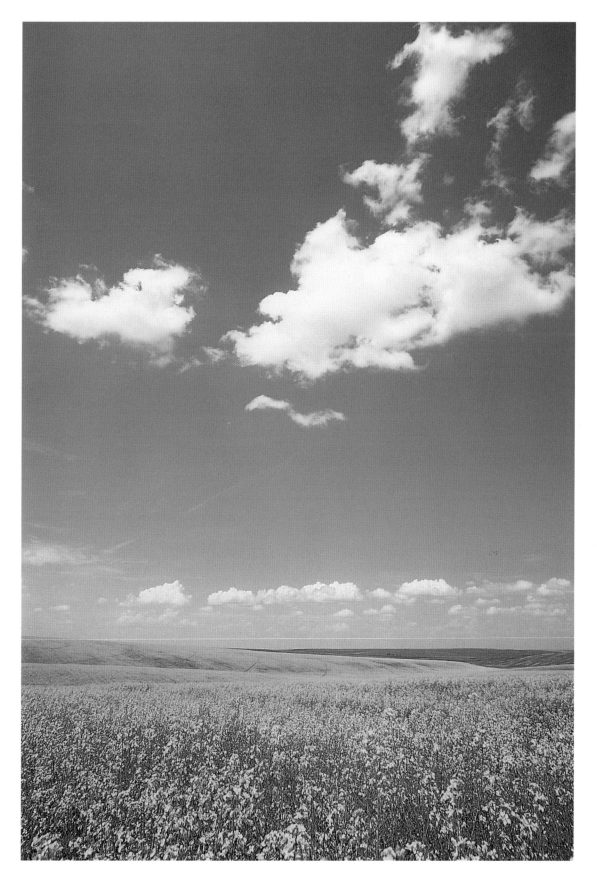

There are about 37,000 farms in Washington, which contribute 3 percent of the state's gross annual products.

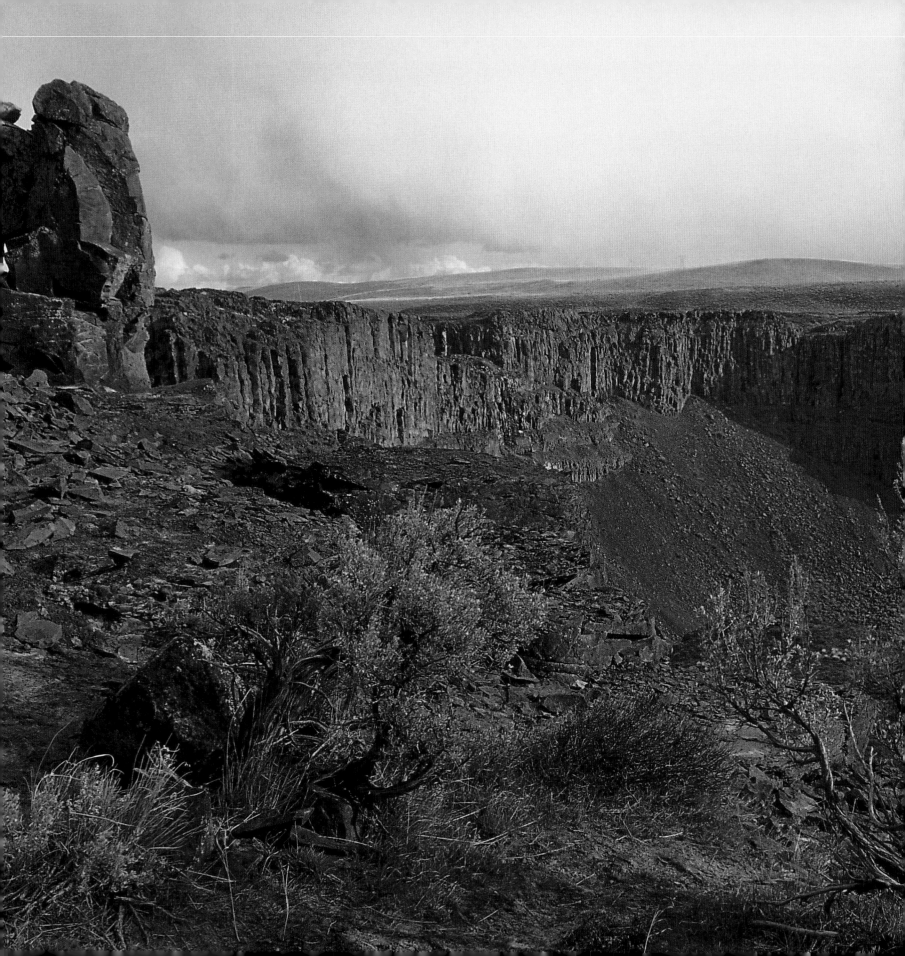

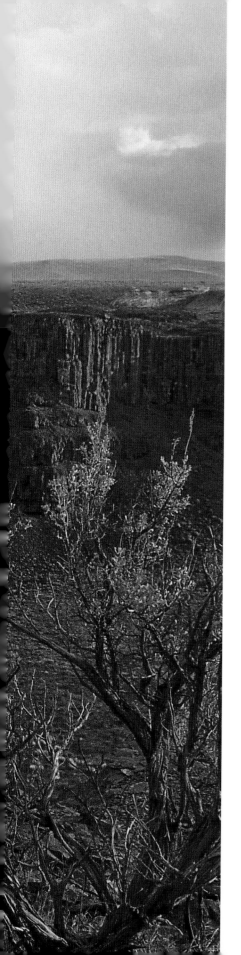

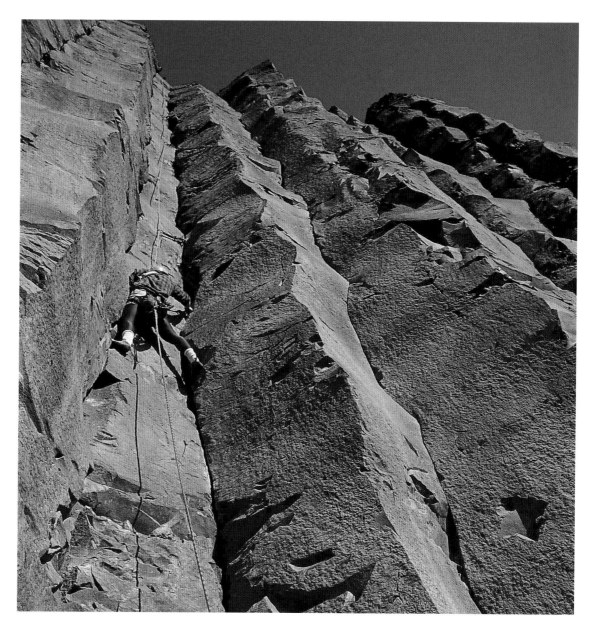

A rock climber scales a route known as "Party in Your Pants," one of many climbs in the Frenchman Coulee.

Frenchman Coulee in Grant County is one of the driest places in the state, with less than eight inches of precipitation per year.

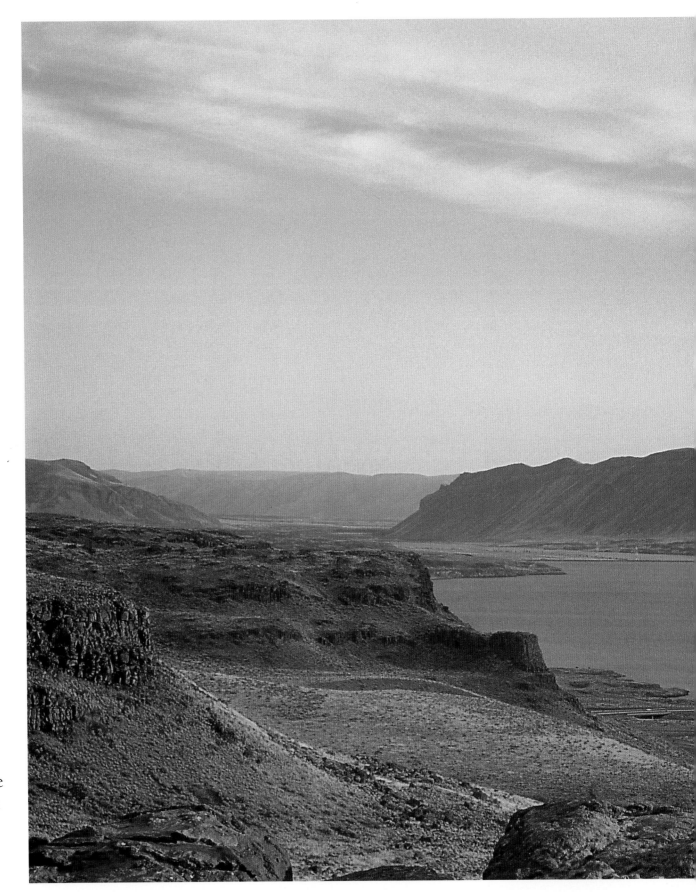

Horses lived in Washington up to 65 million years ago. Some are believed to have traveled across the ice bridge between Alaska and Asia. Those left in North America died out. They were reintroduced with the arrival of the Spanish in the 1500s.

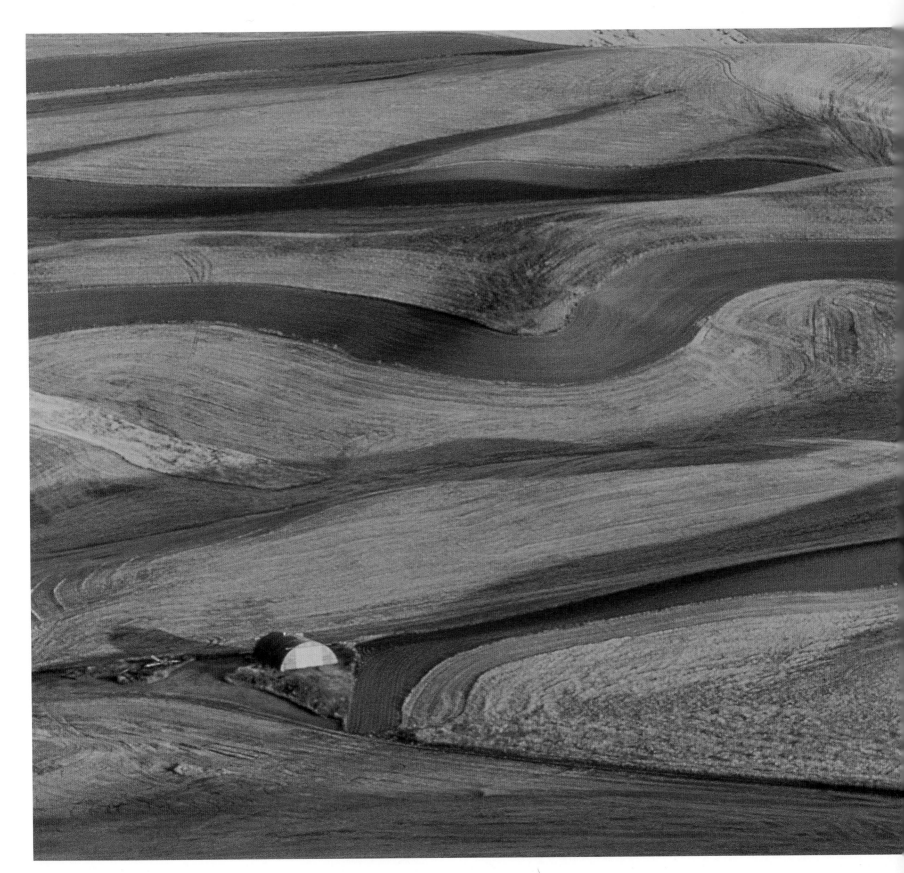

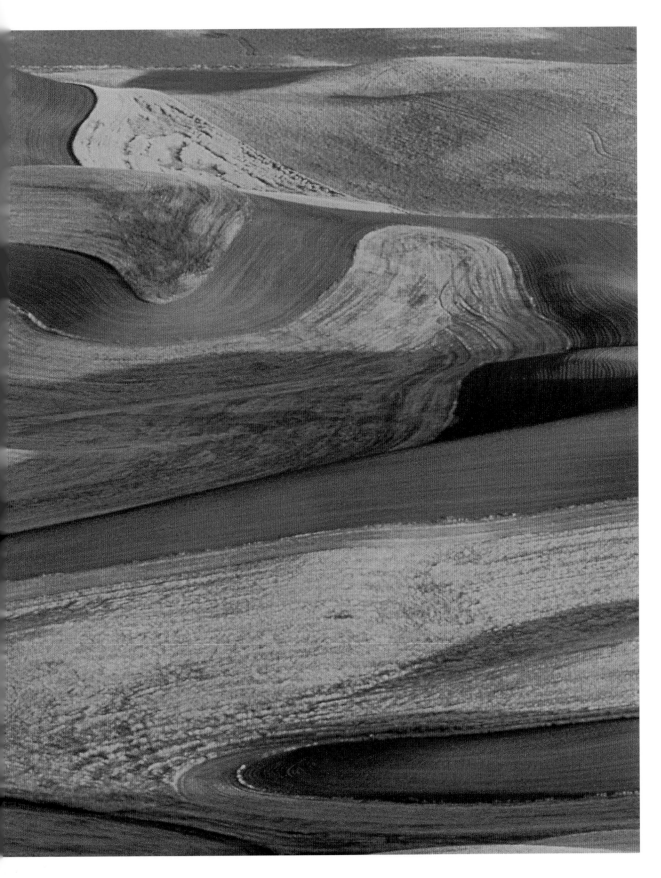

Washington may have been one of the first populated regions in America. Scientists have discovered remains of people in the Palouse area that date to 10,000 years ago.

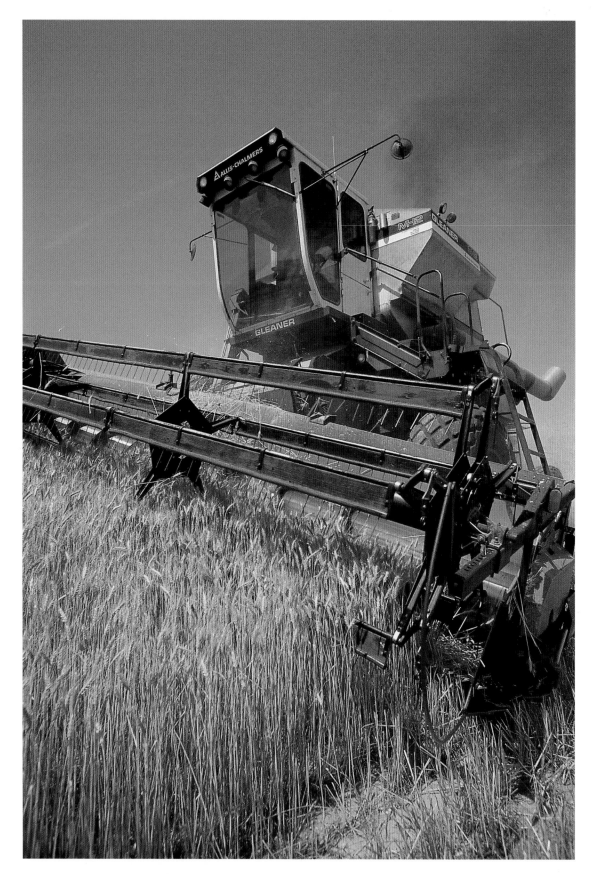

Wheat is one of
Washington's most
lucrative crops, along
with other field crops
such as potatoes,
hay, corn, barley,
mint, and lentils.

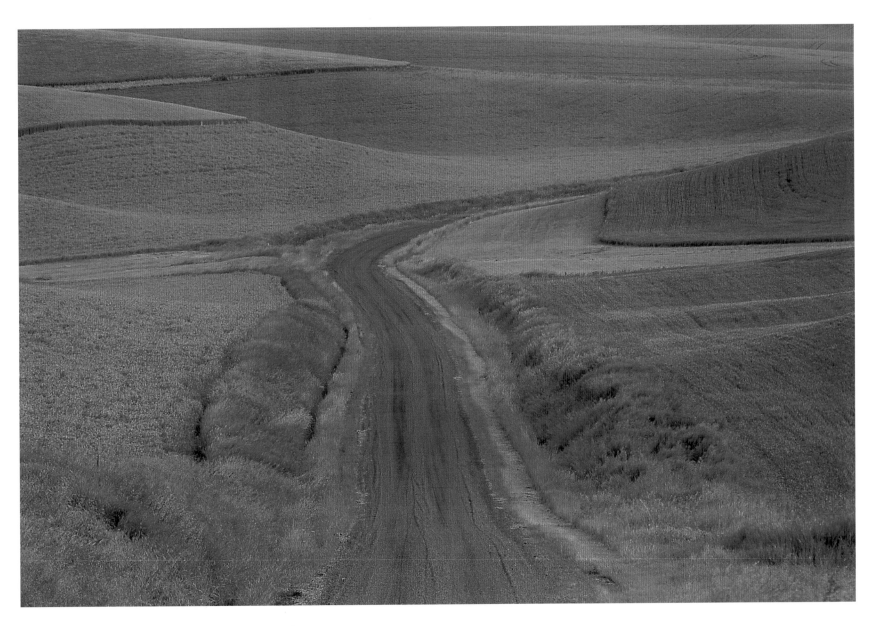

The volcanic soil of the Palouse makes it a rich agricultural region. The name Palouse is derived from the French word *pelouse*, referring to the tough grass native to these rolling hills.

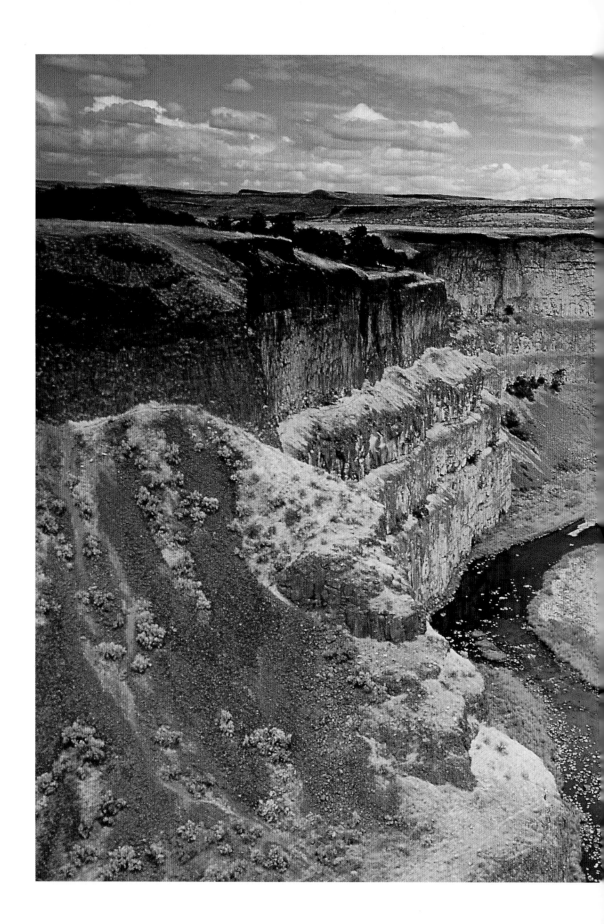

The Snake and Palouse rivers converge near Lyons Ferry and Palouse Falls State Park. Spring runoff creates a swathe of blue through the dry hills of the region.

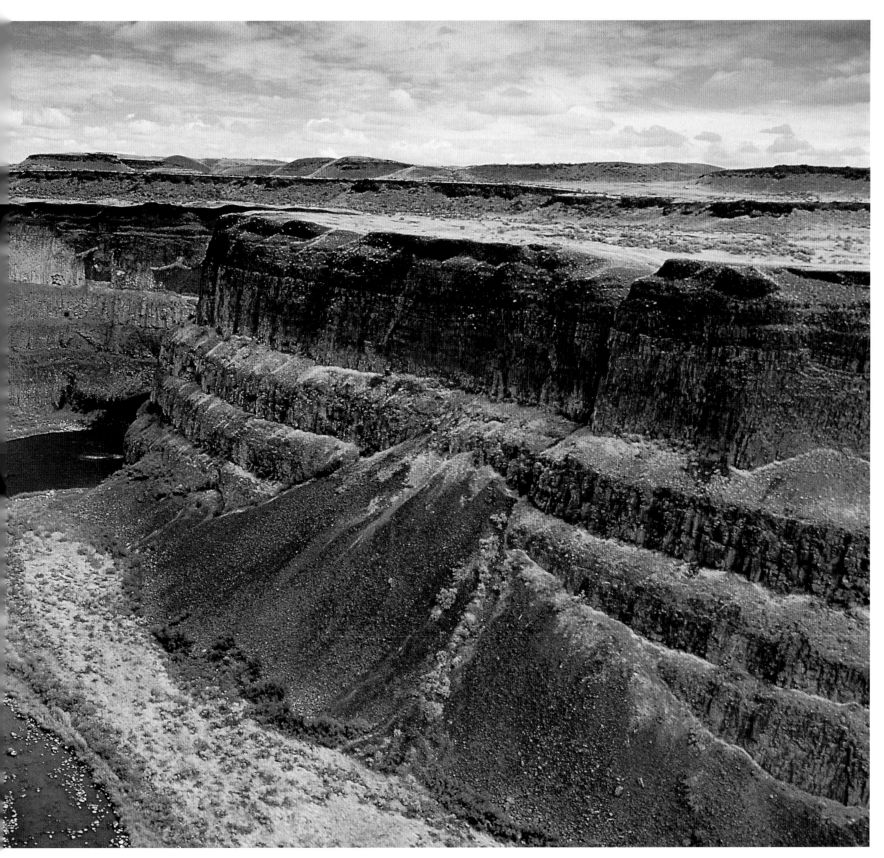

The wind, originating in the southwest
and moving across these rolling hills,
is responsible for depositing the region's
rich soil. Careful measures, such as
strip farming, prevent its erosion.

Three national parks, three national
recreation areas, and more than 100
state parks help draw several million
visitors to Washington each year.

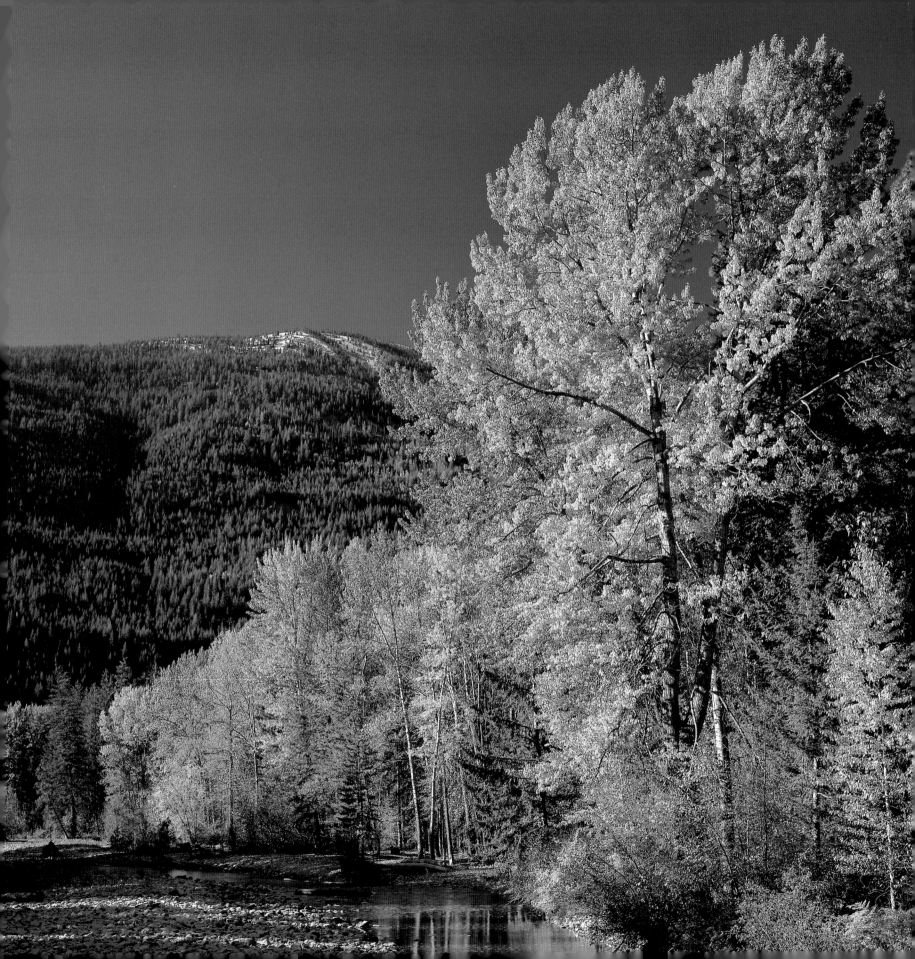

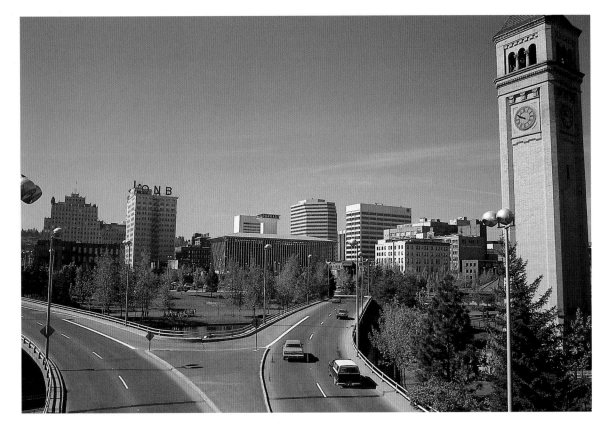

The state's second-largest city, Spokane boomed in the late 1880s, when it became a stop along the Northern Pacific Railroad and a commercial center for farmers. The city is now home to about 193,000 people.

Seattle pioneer C.T. Conover dubbed Washington "the Evergreen State" for its abundant forests. The nickname was made official by the legislature in 1893.

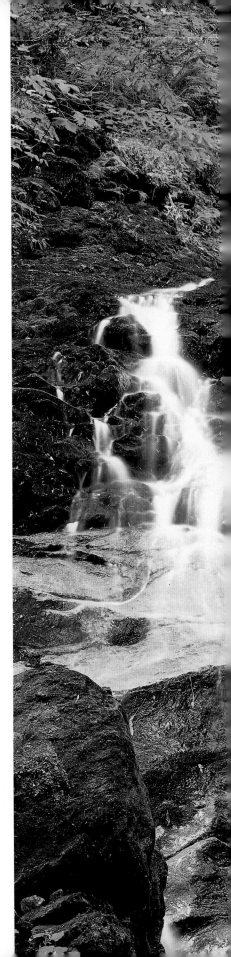

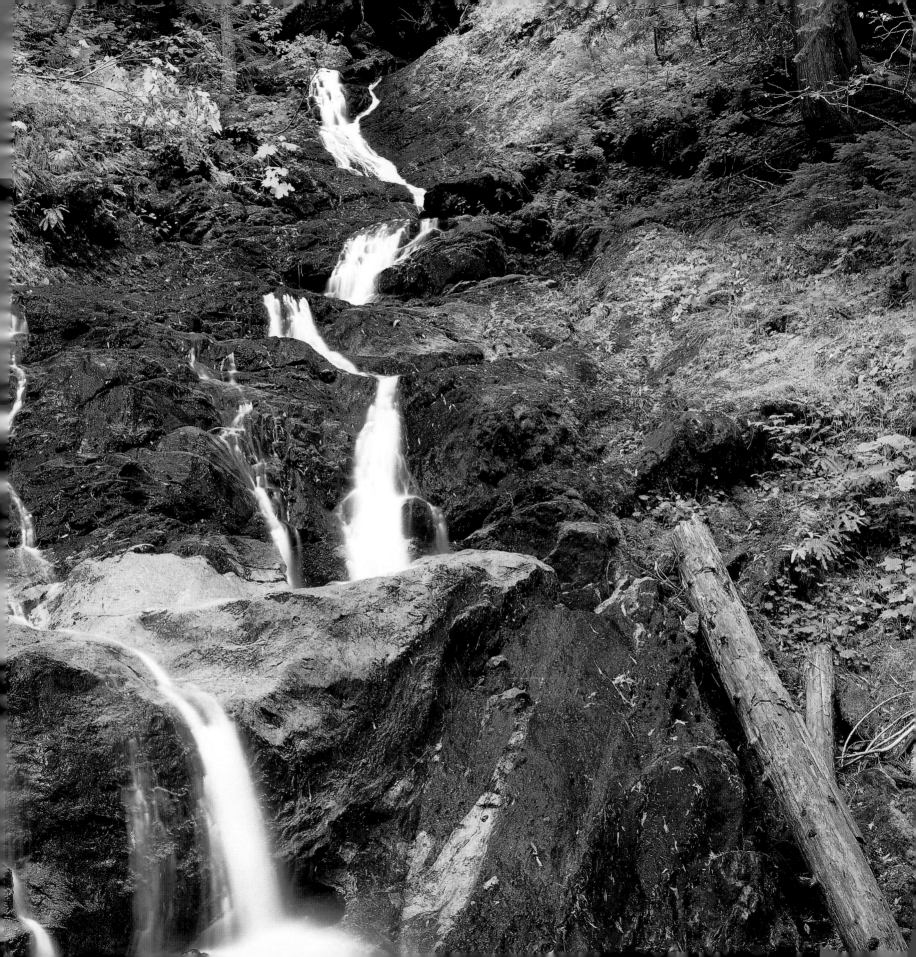

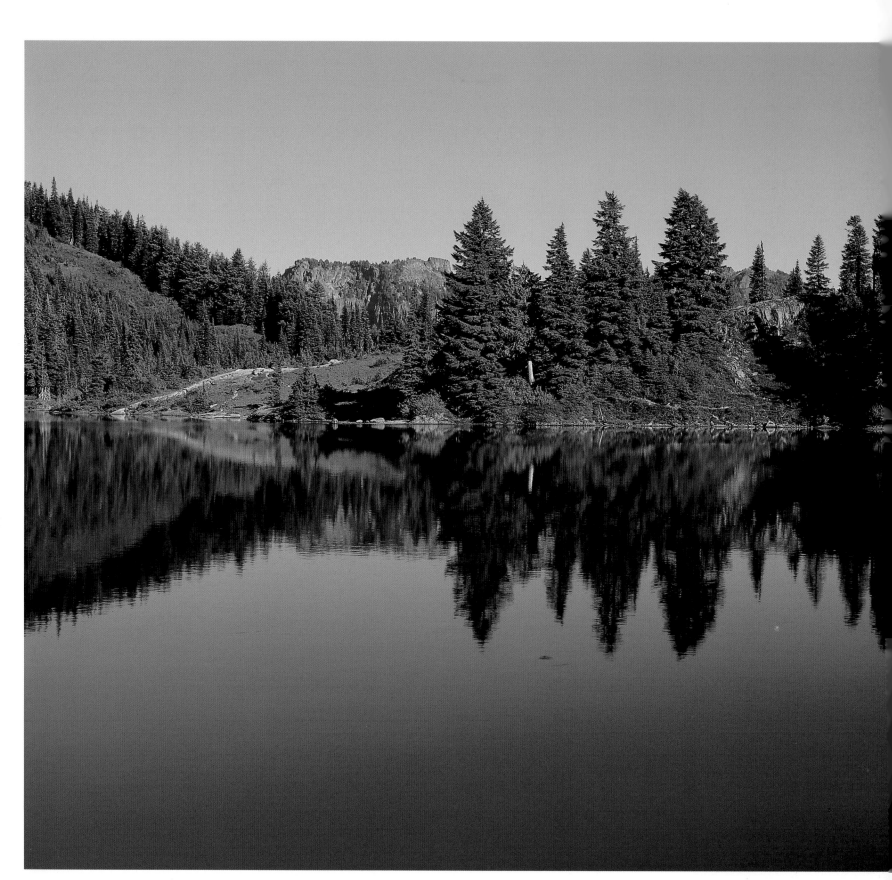

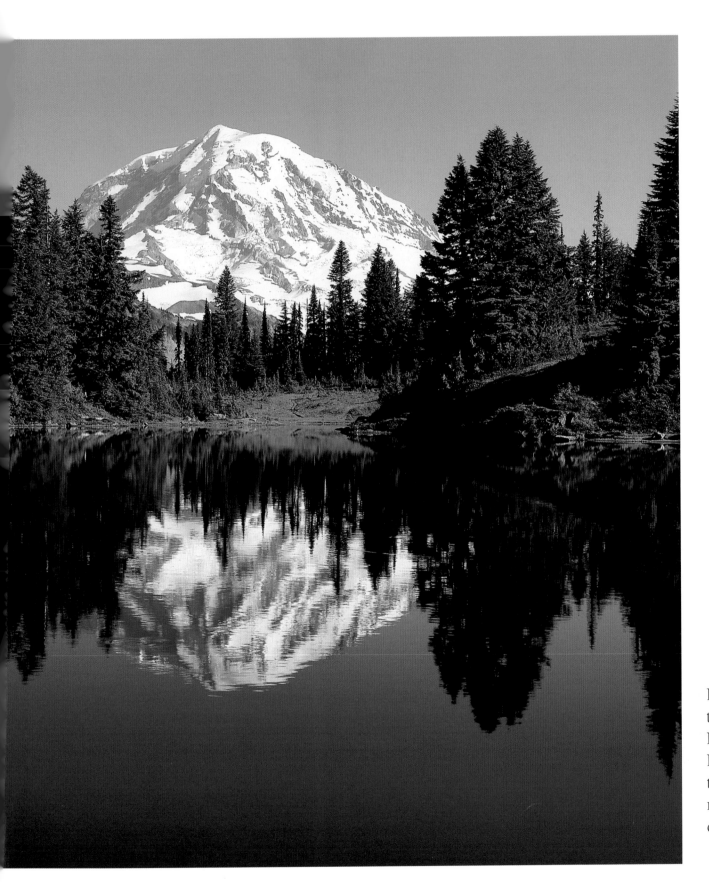

Images such as
this one of Mount
Ranier and Eunice
Lake have come
to symbolize the
natural beauty
of Washington.

Photo Credits